Photography

Tel: +44 (o) 1273 72 72 68
Fax: +44 (o) 1273 72 72 69
E-mail: sales@rotovision.com
Website: www.rotovision.com

ISBN 2–88046–480–3

Book design by Dan Moscrop at Navy Blue Design Consultants

Production and separations in Singapore by ProVision Pte. Ltd.
Tel: + 65 334 7720
Fax: + 65 334 7721

Introduction

This is a book that's as much about images as it is about technique. It's as much about having an eye for a picture as it is about having a mastery of the technicalities of black and white.

And hopefully, for all the things that are passed on through the words of the photographers who created this collection of incredible images, one of the main benefits of the book will be its ability simply to inspire. If, having seen the quality and the sheer breadth of imagery that makes up these pages you feel the irresistible urge to pick up a camera and to go off and try some of the ideas for yourself, then the book will have achieved its purpose in style.

Landscape has so many aspects to it that in many ways it's difficult to produce one single book that will do the complete job. Certainly it would be almost impossible for a single photographer using his or her own examples to try to explain the variety of ways that this subject can be tackled. A landscape can be many things, as you'll see throughout this book. It can be a picture that has been anticipated and that has had to be waited for, sometimes for years, until every element has finally come together in one glorious picture.

It could just as easily be a detail – such as a row of trees standing sentinel in a forest – that takes up just one tiny corner of some vast panorama. It could be a picture that makes use of natural elements such as mist, snow and rain, which will affect the scene dramatically and then, just as quickly, disappear again. Landscape can have at its core a magnificent location, such as Yosemite or the west coast of Scotland, that has acted as a magnet to photographers and artists before them for hundreds of years. Or it could be a scene, such as the old slate quarries of Wales, that draws its drama from the influence man has exerted over the years.

By the same token there's no set equipment that has to be used. A landscape can be taken using no more than a pinhole as a lens and yet still become one of photography's all-time classics, as proved by the story behind 'The Onion Field'. It could just as easily, of course, be originated on a top-of-the-range camera that costs thousands of pounds and which is usually more at home in the confines of the studio.

Landscapes can be pursued for years or they can be fleeting moments that are never repeated. They could even be part of a series that will keep a photographer occupied for years. Just as a fisherman is prepared to take the necessary time to wait for something – or even nothing – to happen, so the landscape photographer depends on his or her reserves of patience, a virtue that is every bit as vital to develop as technical prowess.

Great landscapes usually take time to happen and the tantalising fact is that, even when they do, the photographer knows that, on another day when the sun is coming from another angle, the clouds have formed a different formation or the wind is blowing from a new direction, every location will yield pictures that are different again. It means that landscape photography has no logical finishing point, and the challenge to many is to visit the same places many times to see how many different interpretations they can put on film.

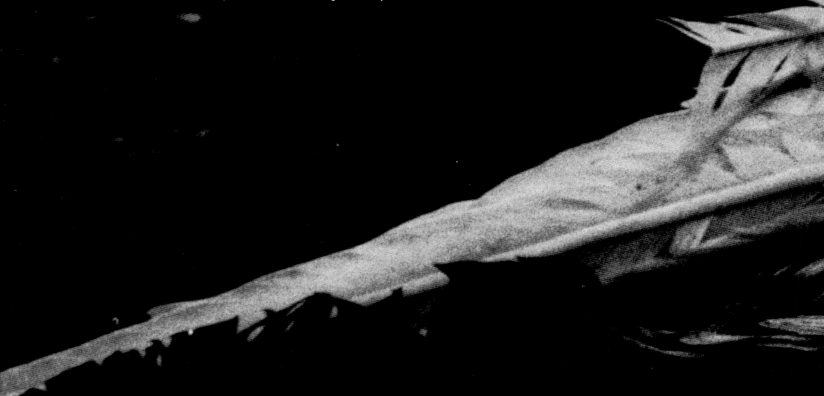

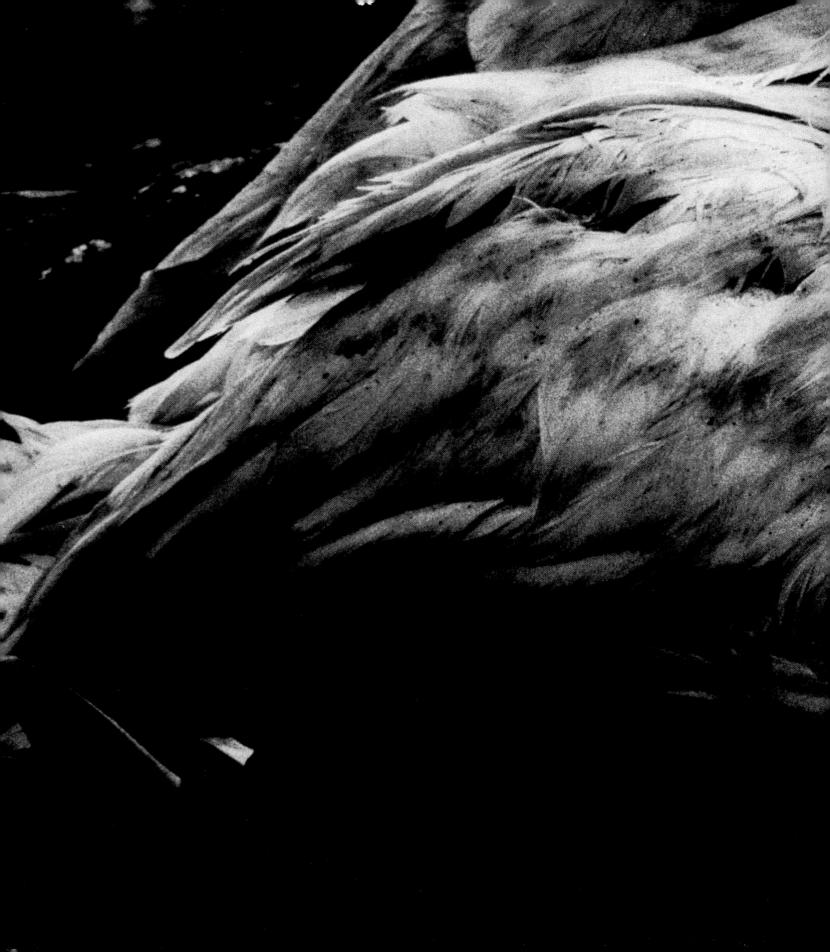

That's the beauty of this and so many other photographic subjects: the individual can make of it what they will, there's no set agenda that has to be followed. Even the golden rules that others have established over the years for photographers to follow are there to be broken and turned on their heads, as so many of the photographers featured here take the greatest delight in proving over and over again.

So much for the subject: what about the medium? What is it about black and white that makes it so enduring? Sheer logic should dictate that, with colour film so accessible and of such high quality now, that black and white should have been relegated to the history books long ago. But instead the opposite has happened. It's taken on a new life of its own, and is gaining a steady and growing following across the world.

Black and white is now seen as the natural medium for fine art prints and, as the digital side of photography becomes ever more important, those who choose to indulge in silver halide and the skills of the darkroom will increasingly be seen as artists in their own right.

A whole new generation of photographers are discovering that black and white can offer them a different way of looking at the world, one in which the simplicity and subtlety of tone and shadow triumphs over the distractions of colour. Time and again black and white somehow captures a mood and a feeling that colour, for all its accuracy, simply can't. Perhaps that's exactly the point: photography is about so much more than a simple rendering of what's in front of the camera. We want to achieve an interpretation of life, and colour sometimes gets in the way.

There's also a lot more flexibility built into black and white in the way that it can be manipulated and made to become what we want it to be. Instead of the computer screen, the traditional photographer has the darkroom, where all kinds of miracles can be performed. The rediscovery of ancient toning methods and half-forgotten early printing processes has provided an extra dimension, and allowed photographers to produce pictures that wouldn't look out of place in an art gallery.

As a bonus, many toners will also give a print a life expectancy of well over a hundred years, provided that the ground rules for display are followed. A glance through the images in this book will show that black and white, thanks to these toning methods, can be surprisingly colourful at times, and equally impressive is quite how effective the final results can be. This is photography proudly proclaiming its history and heritage, and establishing a niche for itself that technological progress in the world of imaging won't erode.

The future of black and white looks secure, and its following will continue to grow as more and more photographers discover its advantages. So, listen to what the photographers in this book have got to say, pick up your camera and get out there and find out what black and white can offer for yourself. You won't be disappointed.

Terry Hope

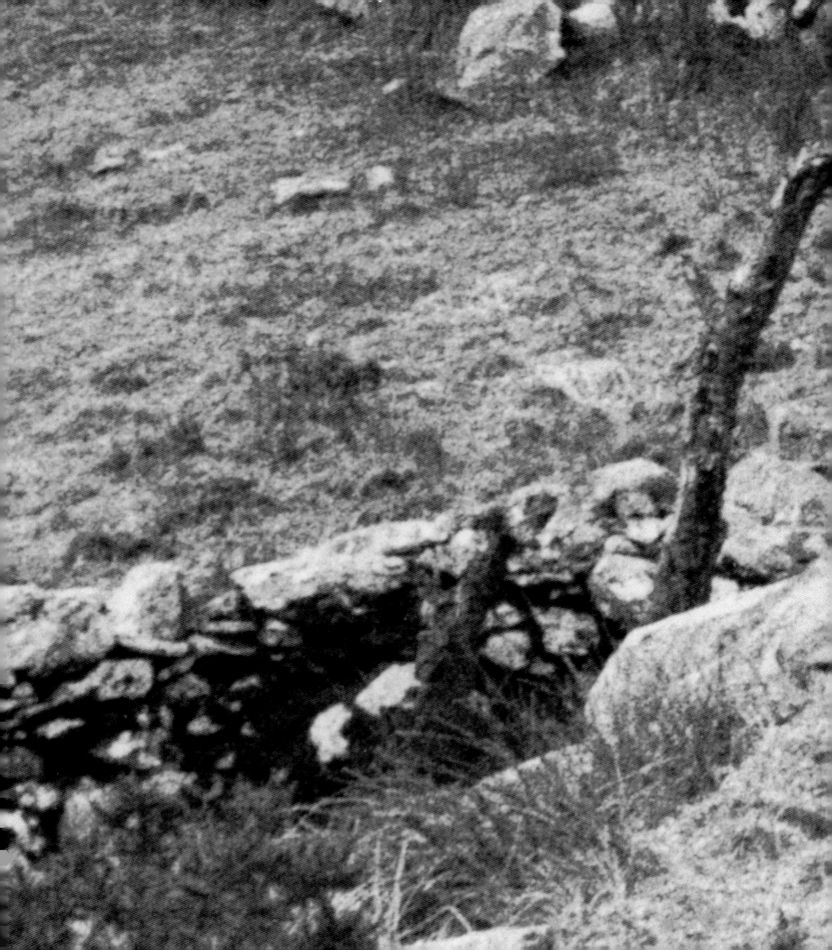

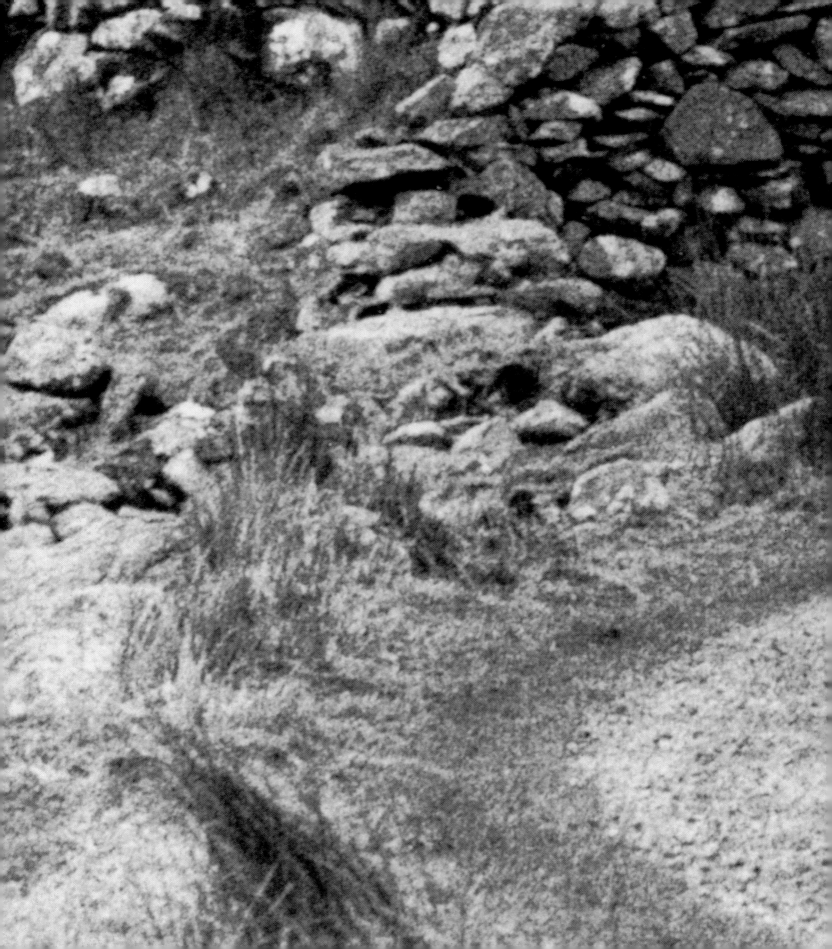

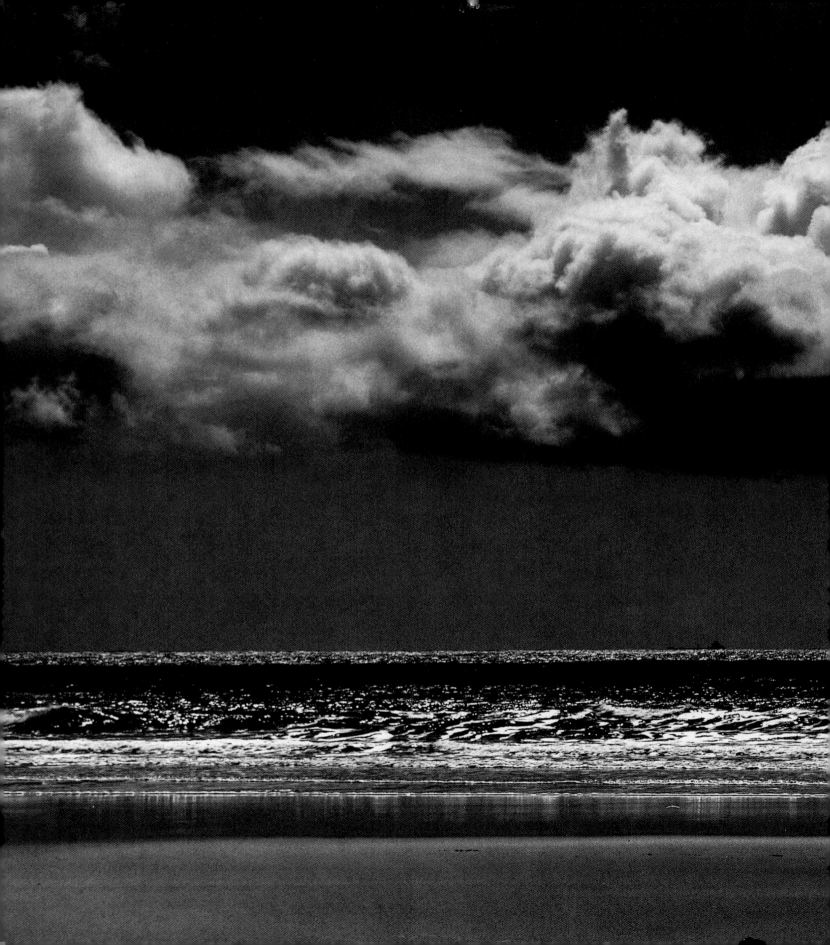

Composition

Composition is one of the most classic of the photographic arts. There are numerous rules that can be followed but, as this section makes clear, most are there to be broken. The best photographers develop the art of composing through sheer instinct – put simply, if it looks right, that's all that matters.

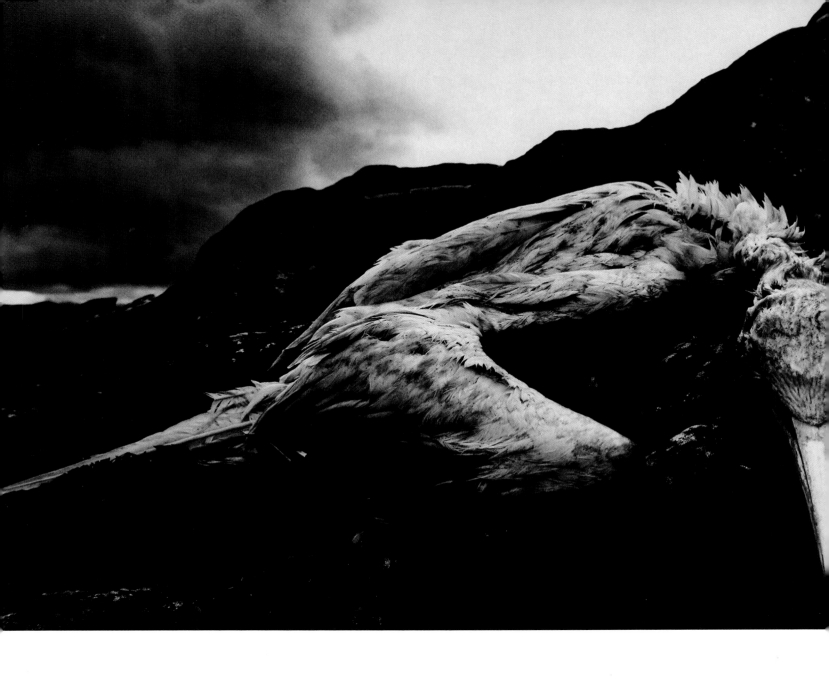

Composition

I found this beautiful gannet lying where it had fallen, close to the beach on the wild and rugged Isle of Isla off the western coast of Scotland. Like always when I see something like this I felt sad, but also uplifted by the shape and form of this still magnificent creature. Looking at the scene I felt that I could use the contrast between the jagged outline of the rocks and the textures of the dead bird's plumage as the basis for an unusual landscape composition.

I decided to move in as close as I could go, and to frame tightly on the bird to make it the focal point of the picture. I hate messing with the natural elements of a scene, but I moved the head of the bird just a little to accentuate the sweep of its body, and to tighten the composition up a little. The diagonal line of the rock echoes the angle the bird is lying at, and a relationship has been created between the landscape and the lovely creature that once flew over it. By choosing to move in close and to create such a dramatic foreground I made a picture that I felt was moving while also saying much about what I feel nature is all about: full of beauty but cruel as well at times.

John Claridge

Technique Enormous depth of field can be extremely useful to the landscape photographer, particularly if the aim is, as here, to make a feature of an element in the foreground and to relate it to the rest of the picture. A wide-angle lens is the perfect choice, because by its nature it will offer a greater depth of field, while the perspective it's capable of producing will emphasise the foreground detail and increase its apparent size in relation to the rest of the scene. Set the minimum aperture – here it was f/22 – and focus to the hyperfocal distance and you'll be able to obtain depth of field that stretches from a few inches in front of the camera through to infinity.

Pointer By choosing a viewpoint that excluded any recognisable features – say a tree or a figure – John Claridge has created a scene that is almost surreal in its appearance, and this gives an extra element to the picture. Logic dictates that the dead gannet is probably a foot or so in length, but there's still an air of mystery here: could it be a giant creature lying on a mountain range? Is it a tiny bird seen in close-up lying on a small rock? Without a scale to work from, the eye starts to play tricks and the result is a picture that is disturbing, as well as beautiful.

Composition

Composition

Martcrag Moor, Langdale by Tom Richardson
Mamiya 645, 45mm lens, Agfa APX 100 film.
Exposure 1/125sec at f/8

The foreground is one of the most important elements of a landscape composition. All kinds of things can fulfil the role: a wall, boulders, a tussock of grass, a stream, a tree. You just have to look around and you're bound to find something, and when you do you have to see if you can marry it with an interesting background.

I came across this small cairn on one of my frequent walks across Martcrag Moor and although it appeared a little ordinary when I first saw it, I knew that it would make a wonderful picture when the light was right.

That time came one winter when I found myself walking in the area again. The winter light was harsh and contrasty and coming from a low angle, and because I knew this location so well I was aware that it would be hitting this landscape from the right direction. I keep a record of locations such as this that I plan to return to at different times of the day or year, and that kind of local knowledge is a great help to any landscape photographer. It saves a great deal of time, which can prove vital when the light may only be as you want it for a very short period.

The long shadows thrown by the winter sun threw this cairn into sharp relief and made it a much more dramatic foreground than it had been before, and it made the picture.

Tom Richardson

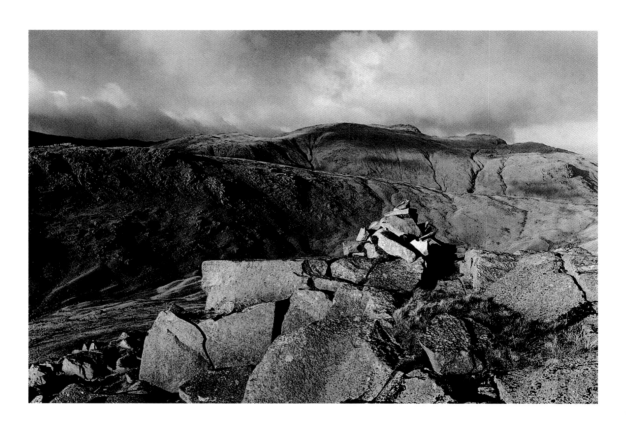

Technique There still was not enough contrast in the foreground to differentiate the tone here from the tone in the background, and so I used a solution known as Farmer's Reducer to lighten this area selectively, using a fine paintbrush to make sure there were no visible areas of overlap. Farmer's Reducer is a mixture of potassium ferricyanide and sodium thiosulphate, which will have a greater or lesser subtractive effect on the print depending on the ratio the two are mixed at. It's best to experiment on a scrap print first and to dilute the Reducer in water if required, to slow its action down. Once the area of the print that is being worked on has been lightened to the required degree, the print needs to be thoroughly washed for ten to fifteen minutes to finish the process.

Pointer The wide-angle lens is my favourite for landscapes. I always feel that its use gets the photographer right into the heart of a place, whereas a telephoto lens makes you feel as though you're intruding on it. Here I had no option in any case, because I couldn't have got far enough back from the cairn to fit it all in using any other lens. But I probably would have used the wide-angle in any case, because it gave me the depth of field I needed to ensure that foreground and background remained in focus.

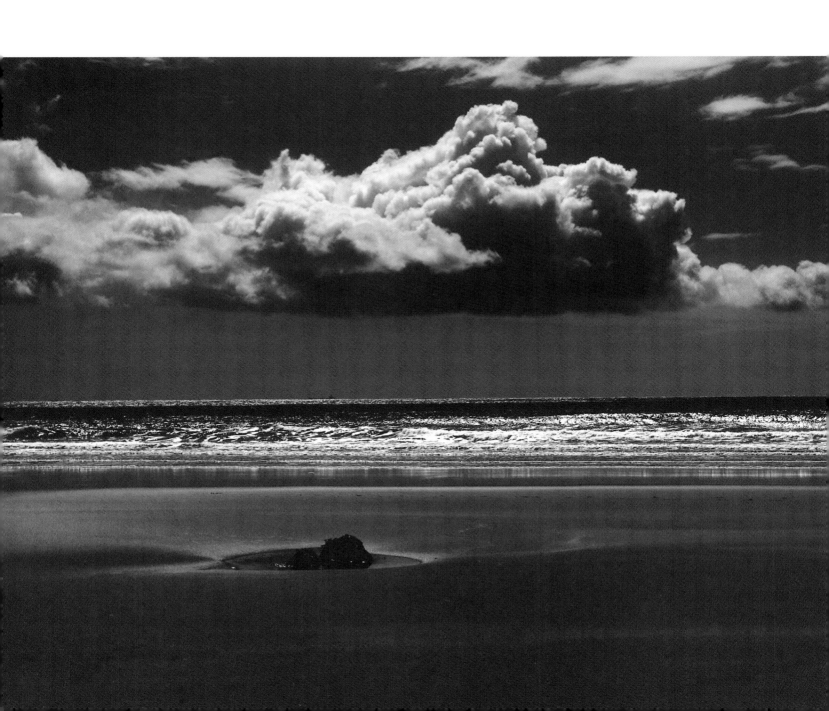

Composition

Cloud and Sea, Wales by John Claridge
Mamiya RZ67, 140mm, Agfa 100 film.
Exposure 1/120sec at f/11

I was attracted to this scene by the levels that I saw within it. Everything was in parallel: the foreground, the sand, the sea, the highlights on the water, the line of shadow on the water and even the cloud above it. The rules of composition state that the horizon should never cut across the middle of a picture like this, but I never even thought about it. I just saw this scene and knew that it was going to work for me, and when your eye tells you that something looks right then rules don't come into it.

The cloud is the unexpected and unpredictable element of the picture and, as such, it's impossible to go out looking for something like this. You have to use your eyes and trust your instinct for a picture, and then be ready to react when you come across a scene like this because it won't last for long.

When working in black and white you also have to learn how to look for tones and develop a feel for how these will translate in the final print. For me, the picture had to be dark and brooding to make the most of the composition. In order to achieve the effect I wanted, I exposed for the highlights on the water when making my print and then allowed the rest of the picture to darken down accordingly. As well as adding density to the foreground, this also darkened the tone in the sky. It almost looks as though the picture has been heavily filtered, but this is a straight shot.

John Claridge

Pointer It's sometimes easy to forget that clouds are as an essential part of landscape as the terrain itself and will often dictate the feel of a picture. Because they're changing constantly, along with the nature of the lighting, it means that the same scene can be depicted in a variety of different ways. It's one of the most exciting aspects of landscape photography, and the single reason why some photographers are hooked for life to this one area of photography. However many times you picture a location, there's always the chance that you'll go back one day and see it in a completely different way.

Technique John Claridge added tone to his sky by printing it down, but filtration will also perform the same role without the necessity for the rest of the picture to darken down as well. A yellow filter, for example, will transmit the green and red two-thirds of the spectrum, while absorbing much of the remaining blue, allowing it to go much darker. A strong red filter will have a similar effect, but will also absorb green, making this darker as well, something that might not be desirable when shooting landscapes that feature a lot of green tones.

'The cloud is the unexpected and unpredictable element of the picture: it's impossible to go out looking for something like this.'

Composition

Trees, Glendalough, Co. Wicklow by Giles Norman
Nikon F70, long end of a 35–135mm zoom, Agfa APX 400 film.
Exposure unknown

Composition is one of the things that I enjoy most about photography. I'm concerned about what's in the frame and what isn't, but I won't spend ages trying to get things right. To me it's an instinctive thing, and I just know when everything feels right.

I was attracted to this scene on the shores of Glendalough by the fact that a slightly elevated position gave me the chance to use water as a backdrop to these trees, which made an unusual picture. The wind was blowing across the water's surface creating texture, and the sun was catching the waves and lifting the contrast, preventing this area of the picture from recording as a block of solid grey or white, which wouldn't have worked nearly so well.

The trees themselves made the perfect foreground, because there was just a single line of them, and this emphasised their spindly nature and allowed the water to be clearly seen between them. I further strengthened the symmetry here by framing tightly to crop the trees top and bottom, and this helped to strengthen the pattern that they formed.

The strong daylight coming in from the right of the picture has picked out highlight detail on the trunks of the trees, and this is important because it's given them more form. It's also helped to highlight some of the foliage on the branches and to create some more texture in the picture in this area.

Quite simply, like the majority of the landscapes that I take, this wasn't a picture that I went looking for, I simply happened across it. That's the way landscape works for me: I travel light to an area such as Glendalough that I know is beautiful and full of potential, and then I simply go looking for things that I find visually appealing.

Giles Norman

Technique The 35–135mm zoom lens I exclusively use for landscapes is extremely versatile and allows me to frame precisely the picture that I want in-camera. It means that the pictures I sell in my gallery are printed up full frame and no cropping is necessary. The lens is short enough to allow me to shoot everything hand-held and it means that I can travel with just my camera and lens and a body bag to hold film, leaving me the opportunity to concentrate solely on the pictures I'm after.

Pointer If you stick to a regular set up, using it will become virtually second nature. All of the landscape pictures I've taken for the past ten years or more have been taken with the same camera/lens/film set-up, and I'm happy to stick with what, for me, has become a very effective kit. The images are the only things that matter to me: the camera is simply a tool to do a job and the more complicated you make things, the harder you end up having to work yourself.

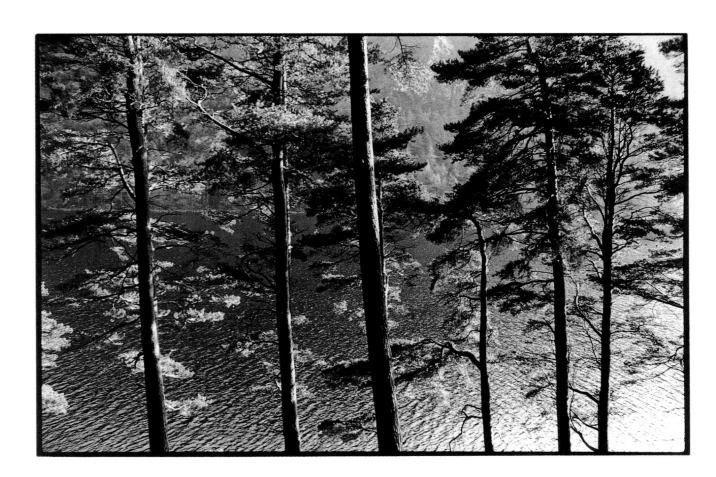

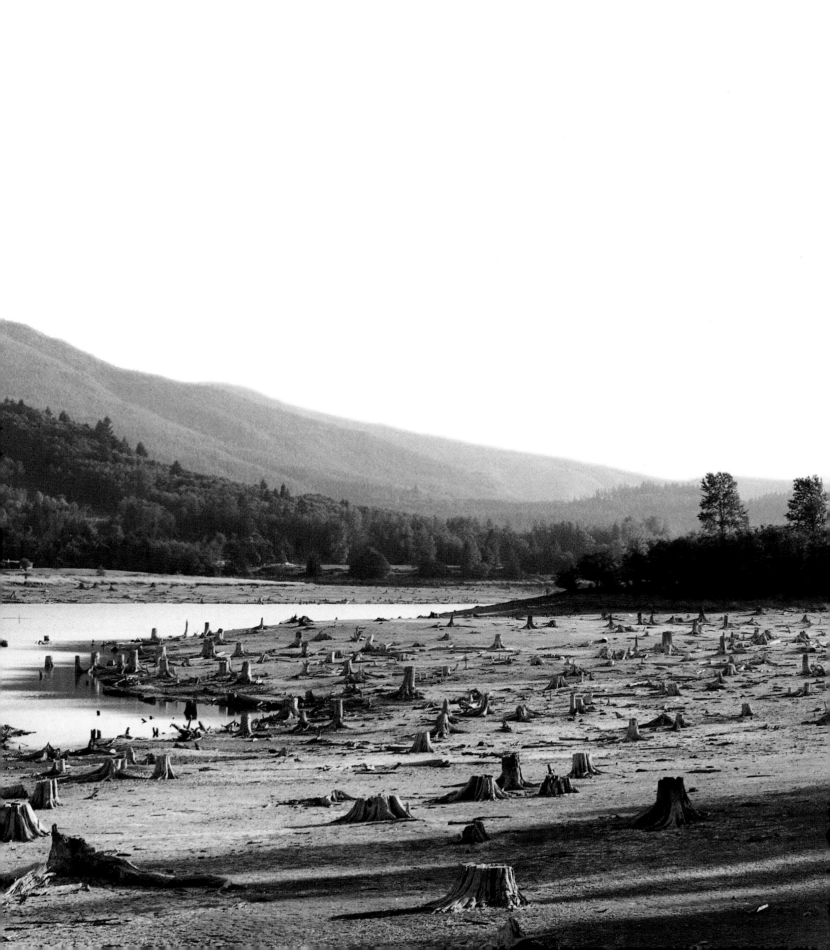

Composition

Clear Cut, Washington State by Bob Hudak
Pentax 6x7cm, 200mm lens, Ilford FP4.
Exposure 1/8sec at f/32

I composed this picture very simply, but with a view to making the most of the amazing scene I'd just come across. This was my first encounter with a clear cut – an area that had been completely cleared by logging – and the sight of row upon row of tree stumps heading off into the distance as far as the eye could see was awesome. I decided to use a slightly long lens to pull things slightly tighter together, and took up a viewpoint that allowed me to feature the stumps as the immediate point of interest in the foreground while also capturing something of the vast scale of the clearance that had taken place. So it is that the bottom two-thirds of the picture features nothing but the stumps. Hundreds of them, all that remains of the forest that once was here, while beyond them in the distant background the landscape is still beautiful and the trees still stand, perhaps waiting their turn for logging. It was a viewpoint I selected very quickly and, after I'd decided on my composition, this was the only place I took pictures from at this particular location. I feel that landscape photography isn't solely about the beautiful things that you encounter with your camera. If you have a feeling for the countryside, sometimes you have to show some of the negative things as well.

Bob Hudak

Pointer We're so used to landscape photography being a slow and methodical task, that it's easy to forget that sometimes you have to be quick to get the picture that you want. I saw this particular scene as I was driving on the busy highway out of the town of Olympia, the capital of Washington State, and I was so struck by the enormity of what I'd seen that I pulled my car over and went back to look for a picture. After looking around I decided that the only place that would give me the viewpoint I wanted was the central reservation of the highway, a dangerous place to be, and it was obvious that I wouldn't have time to set up my usual field camera. That's why I used the 6x7cm Pentax, which is much quicker to set up and operate, and I had to wait for a lull in the traffic passing in front of me before shooting each picture.

Technique To ensure that I captured everything from close foreground to distant horizon sharply – essential for the full impact of this scene to really hit home – I set the minimum aperture of f/32, which guaranteed enormous depth of field. At these kind of small apertures you're certain to have to use a slow shutter speed, and so a sturdy tripod is an essential piece of kit, along with a cable release to ensure that the shutter is fired with the minimum of vibration.

Composition

Dinner Time by Frank Meadow Sutcliffe
Whole Plate (6½ x 8½in) camera.
Film and exposure unknown

A landscape doesn't have to be devoid of people. This sublime composition achieved by master Victorian photographer Frank Meadow Sutcliffe has used the countryside as a backdrop to a rural scene, the drawing of a plough by horse in the traditional style, and the characters here are an essential part of what is still a striking landscape picture. They're taking up the role of foreground interest, one that in a straightforward landscape composition would usually be played by a natural element, such as a rock or a bush, and by placing them as he has, Sutcliffe has linked them inextricably with their surroundings.

First it's useful to look at the compositional devices that Sutcliffe has employed here. The picture is a series of diagonal lines that lead off to a convergence point somewhere just beyond the right-hand edge of the picture. The eye moves naturally to the two main characters and then is led irresistibly through the picture, first to the horses and then to the distant horizon, drawn by the lines that lead to this point. By leaving space in front of the horses there's an area for them to move into, a classic compositional device, and it's ensured that the picture doesn't feel confined or cramped. By the same token space also exists behind the character on the left: none of this space is wasted, rather it's essential in helping to place this vignette in its isolated environment.

Finally Sutcliffe has taken great care with his placing of his figures. The hill rising behind acts as a backdrop to them, and provides useful tone for them to be seen against. Had they been photographed against a flat area of farmland, it would have been the sky forming this backdrop and the surroundings would have had a much smaller role to play.

Technique Cameras at the turn of the century featured minimum f-stops that could go as low as f/64, a setting that would guarantee great depth of field. Sutcliffe therefore could have registered this entire picture pin-sharp, but he chose instead to focus tightly on his primary area of interest, the two farm workers, and to set a wide aperture that would allow virtually everything behind them to disappear into soft focus. Had the zone of sharpness extended even to the first line of bushes, the detail recorded there would have started to fight against the characters Sutcliffe wanted to emphasise, and so it was vital that depth of field was kept shallow. He would have seen through his focusing screen exactly the effect that he was achieving: many current SLRs also feature a preview button that will stop the lens down to the set aperture to enable depth of field to be precisely ascertained.

Pointer The choice of a hazy day on which to shoot allowed use to be made of the natural diffusion in the background, while Sutcliffe's decision to take up a camera position that utilised backlighting ensured that the effect was maximised. This served to further emphasise the characters, as all detail behind them was softened and virtually removed.

The converging lines in the planes of a landscape lead the eye irresistibly through the picture

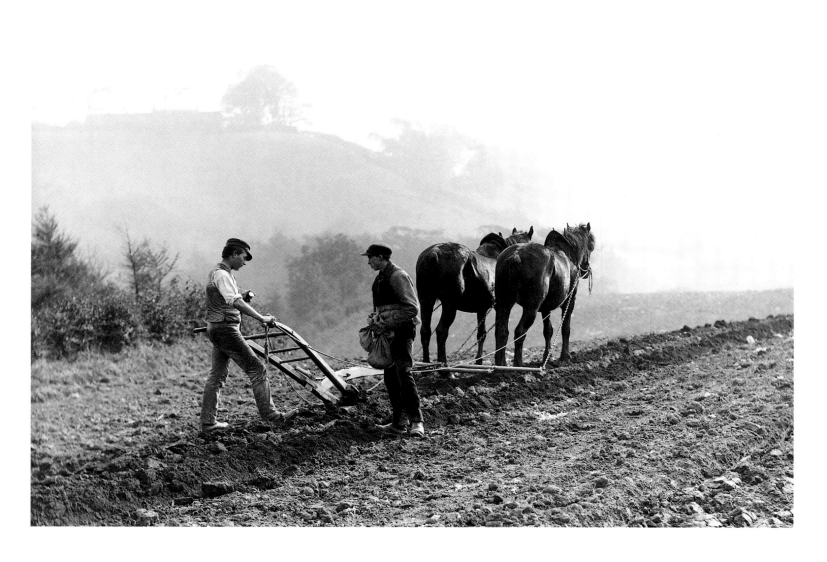

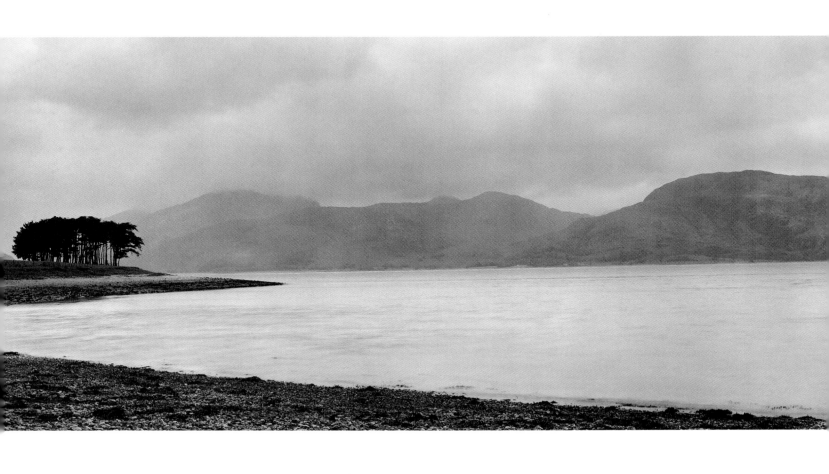

Composition

Argyll, Scotland, 1990 by John Swannell
Linhof 6x12cm, 65mm lens, Agfa APX 25 film.
Exposure 1sec at f/22

With landscapes you tend either to shoot something that has such a strange and wonderful atmosphere that it makes people want to go and spend some time there themselves or else you try to capture the mystical side of a place on film. This is probably far harder to do, and it was something that I was attempting to achieve with this picture taken in Argyll in Scotland.

The composition is the twist that makes this picture slightly different, and I walked up and down along the shore of the loch thinking about what I wanted to do very carefully before deciding on this particular viewpoint. I decided to take up a viewpoint that allowed the promontory with the trees to sweep in on the left and to become the focal point of the picture. It's unusual to have the main area of interest so far over to the edge of the picture, but I felt that it worked, because it's subtle and plays against the wide area of nothing in the middle of the picture. Take it out of the composition altogether and the picture falls flat, there's nothing the eye can focus on.

On this particular day I came back with a picture for myself that I felt was strong and which meant a lot to me personally. Often with landscape it doesn't work like this and ultimately you end up with a lot more failures than successes. You have to learn to cope with that disappointment. It does mean, however, that you get a very good feeling when once in a while you look through the viewfinder and you know that everything's starting to happen.

John Swannell

Technique The Linhof, like the 35mm Leica, is not a single lens reflex camera, so there's no mirror to flip up each time the focal plane shutter goes across, and no vibration to worry about. What this means is that, so long as you're using a good quality tripod, it's possible to set really slow shutter speeds and still be totally sure that you're not going to get camera shake. Consequently the one-second exposure I used here is fairly standard for me when I'm shooting landscapes and it allows me to set apertures that are small enough to guarantee enormous depth of field.

Pointer Landscapes are not at their best at all times of day and all through the year, but if you shoot enough of them you do become fairly adept at knowing when a place is going to be worth visiting. I make a point of keeping a notebook that contains a list of locations and the ideal time to photograph them and then, whenever I can, I'll take a trip back with the camera. It may take me years to finally get the picture of a location that I want, but at least I'm aware of the opportunities and can sometimes plan my schedule accordingly.

'It's unusual to have the main area of interest so far over to the edge of the picture: it works because it plays against the wide area of nothing in the middle of the picture.'

Composition

Spanish road by Adrian Ensor
Rolleiflex 6x6cm with fixed 75mm lens,
Ilford HP5 uprated one stop from ISO 400 to 800.
Exposure 1/250sec at f/16

The landscape around the Moorish village of Yegen in the Las Alpujarras region of Spain just south of Granada is outstanding and in the autumn when I visited, I had it largely to myself. I wanted to find a way to capture the essence of the scenery on film and when I came across this dirt track leading off into the distance, I knew I had discovered the element that I was looking for. The compositional strength of a device such as this track is tremendous. The eye is invited naturally into the scene and led through the foreground into the middle of the frame, where the Poplar trees become the main focus of interest, and then beyond there are the distant hills making up the backdrop.

I took the picture at around 9am, when the sun was still low in the sky, and the backlighting that this provided has picked out the trees and highlighted the mist in the distance. For me, pictures either work or they don't and I have no concept of the traditional rules of photography. When I see something that attracts me, I take my picture and often I find that that's the best way to work. I returned to this viewpoint later in the day, when the sun had moved around to give a more frontal form of lighting, and the scene was nothing like as effective.

I had been travelling around this region having been attracted to visit by the writing of an author called Gerald Brennan, who lived in this region in the 1920s. He described the countryside so vividly that I was afraid I would visit and find it all something of an anticlimax. As it happened it was still everything that he said it was, and that helped to inspire me. He'd arrived in this particular village after a journey of several days by mule and I imagined that perhaps this was the very track that he'd travelled along, something that ensured that this picture means a lot to me.

Adrian Ensor

Technique I usually shoot most of my landscape pictures through a yellow filter. I find that this gives me a base tone in the sky and I can either leave this as it is or work from this at the printing stage to deepen the tone down to make the sky more dramatic. You can create tone simply by giving more exposure during printing, but if you're not building on tone that's there already it's more difficult to make it look natural.

Pointer The Rolleiflex is a 6x6cm camera with a fixed lens, and I find that it imposes a useful discipline on the way that I work. With 35mm it's so easy to change lenses and to alter the whole feel of the picture. I find that the square format the Rolleiflex offers, combined with the standard lens viewpoint, makes you think more about what you're doing. With this camera you have to make decisions as you go along. You shoot less film and work harder to achieve your results and I enjoy that challenge.

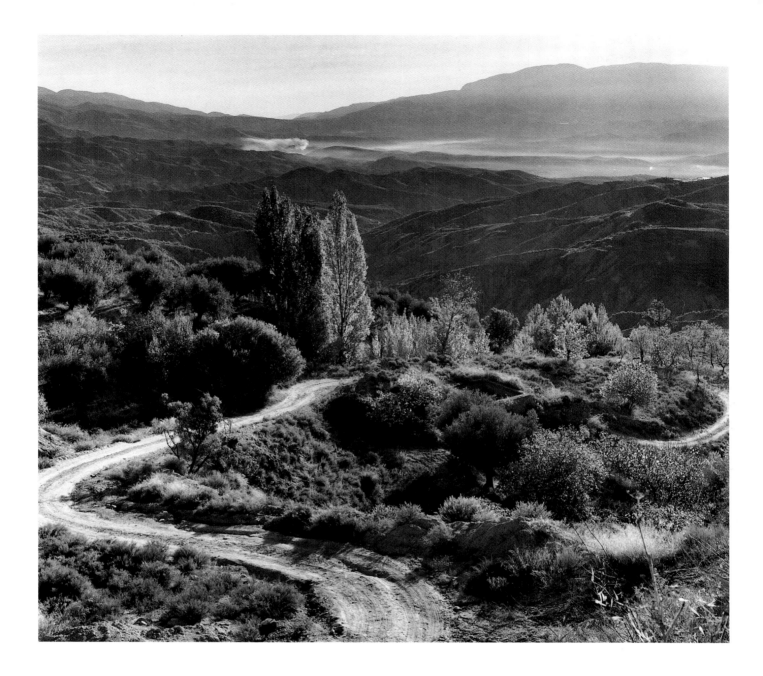

Tone, Texture

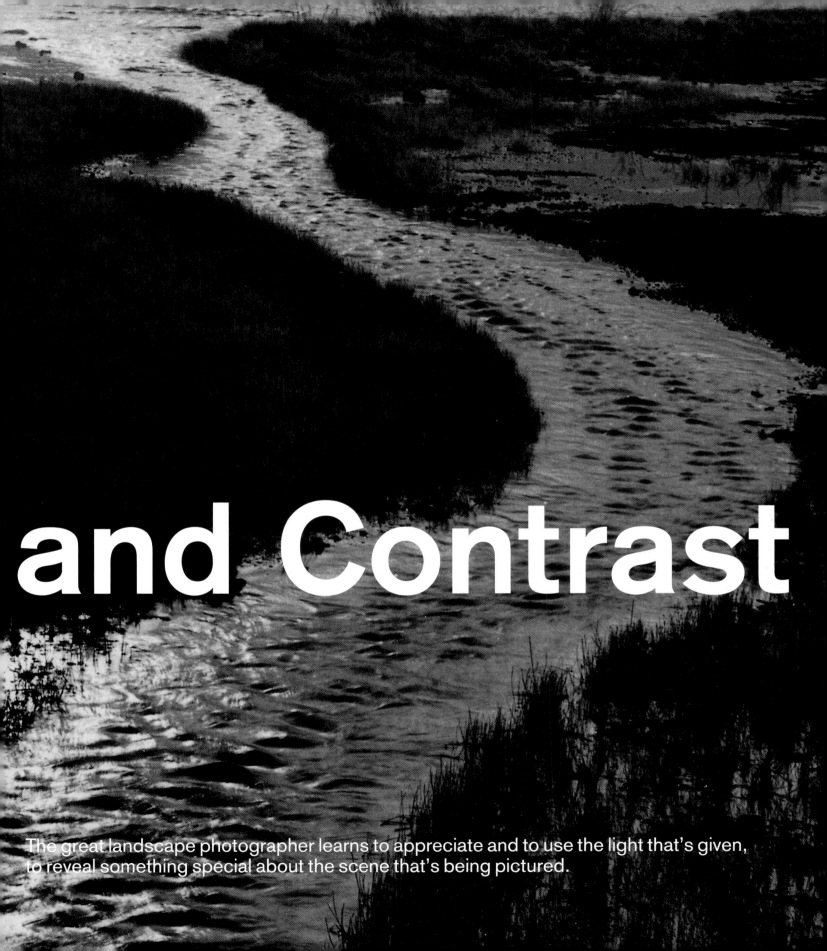

and Contrast

The great landscape photographer learns to appreciate and to use the light that's given, to reveal something special about the scene that's being pictured.

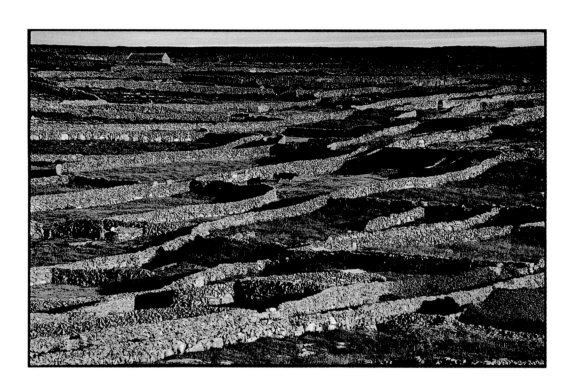

Tone, Texture and Contrast

Innismenann Island by Carl Lyttle
Canon EOS 1, the long end of a 75–300mm zoom, Agfa 100 film.
Exposure unknown

These amazing stone-built walls are, along with the donkeys and the seascapes that abound, the most enduring feature of Innismenann Island, part of the Galway series of islands in Eire. It's a tiny place that measures just one mile across by one-and-a-half miles long, and it's home to just a few houses, some shops that sell fishing tackle and a pub. My brief from the magazine I was working for gave me plenty of freedom, which I relish, though the art director who talked the job through with me before I set off had a clear idea of what he wanted through the pictures he'd previously seen of this location. When I discussed the shoot with him he told me that what he was looking for was an image of the walls that had a gritty feel, and this meant that I had to come back with something that highlighted their texture. With editorial shoots like this, which invariably are carried out on a small budget, the photographer works alone, putting in long hours and shooting things as he goes along. There's no prospect of waiting around for a few days for lighting to change, so you have to make use of what you find. In this case, as the afternoon wore on and the sun dropped lower in the sky, the shadows lengthened and the textures of the scene began to be more fully revealed. By using the long end of a 75–300mm zoom, the characteristic foreshortening effect that the telephoto lens offers allowed me to emphasise the patterns that the walls made, and this ensured that the texture was highlighted still further.

Carl Lyttle

Printing and Processing I printed this picture on lith paper, which gives a high contrast effect without allowing shadow detail to be lost, which is what would happen if you were simply to use a contrasty grade of normal printing paper. This ensured that the picture had extra punch and gave further emphasis to the textures in the scene. It also gave the picture an overall light brown tone that is the characteristic of a lith print, something that I feel adds to the whole effect. Including a tiny part of the clear edge of the negative at the printing stage creates the black line around the picture. I started my photographic career assisting a great landscape photographer, Christopher Joyce, who taught me that if you see a picture you should fill your frame and then stick with it. Consequently I try to carry out my cropping in-camera, which means that I usually print my images full frame.

Websites When I first started out as a professional I was known for my studio still life work, but the problem was that everyone refused to believe that I could shoot landscapes, which were my first love. So, Cori being my father's name, I set up a website using the pseudonym Cori Lyttle – www.cori.co.uk – and I used it to exhibit the landscapes I had taken. I also put together a separate portfolio that featured only landscape pictures. Eventually work started coming in for the mythical Cori and as this took off, I scaled down the studio work I was doing. Now around 90 per cent of what I do is based around landscape, which is much the way I prefer it.

'With magazines there's no prospect of waiting around for a few days for lighting to change, so you have to make use of what you find.'

Tone, Texture and Contrast

The texture of these long grasses caught my eye, as I was looking for a vantage point from which to photograph this derelict crofter's cottage by the shores of Loch Gruinart, the famous bird sanctuary on the Isle of Islay in Scotland.

The winds in these parts can be ferocious, and this day it was blowing in off the Atlantic in 60mph squalls at times. I could see it moving the grass around and decided that this was going to be my picture. I needed to fit a 4x neutral density filter to the 50mm wide-angle lens I was using, because I only had fast ISO 400 rated film with me and it was important that I was able to set a shutter speed low enough to record the movement of the grass.

In the end I was able to shoot at 1/30sec by using a combination of the filter and a small aperture, and this was enough to cause a gentle blurring around the ends of the grasses. Any slower and there was a risk that the camera, even though it was mounted on a secure tripod, would have been disturbed, blurring the entire scene.

I over-printed the sky area of the picture to darken it down and to make the whole picture look a little more threatening and moody. But the day was dull anyway, and this suited the scene. The odd thing about shooting landscapes is that they're usually better off taken when the weather's not perfect, because that way you get more atmosphere in your picture. It's one reason why Scotland is such a great location for landscape work!

Tom Richardson

Technique I wanted the sky to appear as dark and threatening as possible in the picture and so I fitted a red filter. When used with black-and-white materials, a filter lightens its own colour and darkens the remaining parts of the spectrum, and so red ensured that any blue that was in the sky would be considerably darkened down. Red also has the effect of lightening yellow, so its use allowed the grasses to stand out more from their surroundings.

Pointer The wide-angle lens I was using helped to emphasise the all-important foreground here and made it more prominent in the picture. The perspective a wide-angle will offer endears it to any landscape photographer who wants to make a feature of foreground detail.

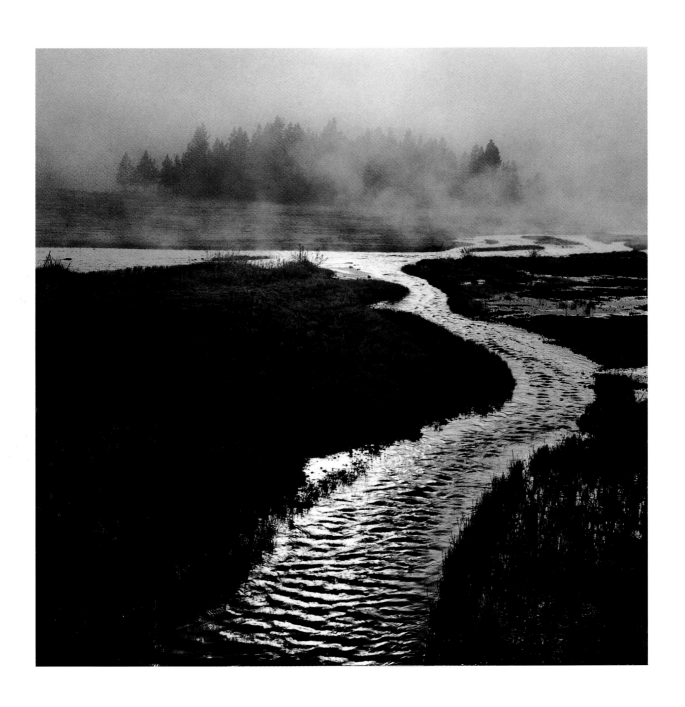

Tone, Texture and Contrast

Misty Morning, Yellowstone National Park by Jerry Olson
Pentax 645, 55mm lens, Kodak T-Max 100 film.
Exposure 1/60sec at f/16

The one thing you can rarely achieve in landscape photography is a prediction of how a scene is going to look at any given time. The odds, however, were slightly less stacked against me when I went to photograph at one of the many geysers that could be found in the park. Here I knew I could virtually guarantee that in the morning at least, I would find some fog hanging in the air, and I wanted to use this to create a moody picture.

Normally fog will lower the contrast levels in a scene, as it has indeed managed to do in the background here. But because I took up a position looking towards the sun, the contrast has actually been increased quite dramatically on the surface of the water, as it has reflected the light. Backlighting, if used sparingly, can be one of the most effective forms of lighting for a landscape, particularly if you want to achieve extra drama in the scene. Here it's helped to highlight the mist and to make it more of a feature, while the background has taken on almost an ethereal quality. The silver ribbon of water now leads the eye into the picture and because it was moving, its surface has become rippled and this has picked up shadow and created a textured element within the picture. Now although the picture is short on detail, it's full of atmosphere and mystery: precisely the effect that I was hoping to achieve.

Jerry Olson

Pointer It's rare that the best landscapes are taken in summer. In Yellowstone, as in so many other locations around the world, the autumn and winter months are the best for photography, because this is invariably when lighting conditions will be at their most interesting and there's a greater chance of elements such as snow and ice having an influence. In areas as popular as Yellowstone, it's also worth bearing in mind that there will be less people to contend with: campsites and lodges will be packed during the summer months while in winter, photographers have a greater chance of having some of the greatest locations to themselves.

Technique Because you'll be looking towards the light source, backlighting can easily fool your meter into indicating major underexposure. In some cases this might be exactly the effect you want: here, for example, the scene has deliberately been underexposed to allow more detail to be retained in the water and to darken down the foreground. If you want your picture to be closer to what is perceived as an 'accurate' reading, however, then it's likely that you'll need to give at least two more stops than the meter indicates. You could also get a good idea of the reading by taking two incident (reflected) light readings from the subject position, one with the meter pointing straight at the camera and the other with it pointing straight at the principal light source. If you split the difference between the two readings, you should be somewhere close to the ideal exposure setting.

Tone, Texture and Contrast

Antelope Canyon by Jerry Olson
Pentax 645, 55mm lens, Kodak T Max 100 film.
Exposure 4secs at f/16

Antelope Canyon, which is situated near Page in Arizona, is a remarkable location. It's anywhere from three- to four-feet wide in some places and up to around twenty feet at its widest point, and it features sheer walls that rise to between fifty and a hundred feet. It's lit by direct overhead lighting for about two hours at midday from June through to the end of July, and the sunlight comes down in strips of light: as it moves around it highlights different forms and textures throughout the day. I've found that the hours between 11.30am to 1.30pm are the best for photography, but there's always a little light peeking out somewhere for around five or six hours.

The area attracts photographers in their droves these days, yet it's still possible to produce pictures here that are unique. There are dozens of slot canyons in the area and each one is beautiful and different from the rest. Some are more difficult to access than others, and some require you to enter from the top with ropes and ladders. It's simply a case of looking around for a different angle and of having the patience to wait for things to happen. Visiting such a location teaches the photographer much about the way that light reacts with natural textures: even a matter of a few minutes can make or break a picture, and the areas that are in shadow ultimately become as important as those that are picked out by the sun.

Jerry Olson

Technique The light in these canyons varies over a huge range and this obviously has an enormous effect on the kind of exposures that need to be given. Some pictures can be taken using a shutter speed as high as 1/60sec, while others require an exposure of fifteen minutes or more. If the area you're photographing in is well lit, then an exposure meter will give you pretty good results. If you're shooting in a darker area, however, then the only answer is to bracket. Estimate as best as you can what the exposure should be and then shoot at two to three stops either side.

Pointer The sand on the floor of Antelope Canyon is as fine as powdered sugar. When you're in a situation such as this — on a beach, for example, or perhaps photographing in desert conditions — you must make sure that you keep your gadget bag closed whenever you're not using it. Dust and sand can and will get into your cameras, and it will inevitably lead to expensive mechanical breakdowns.

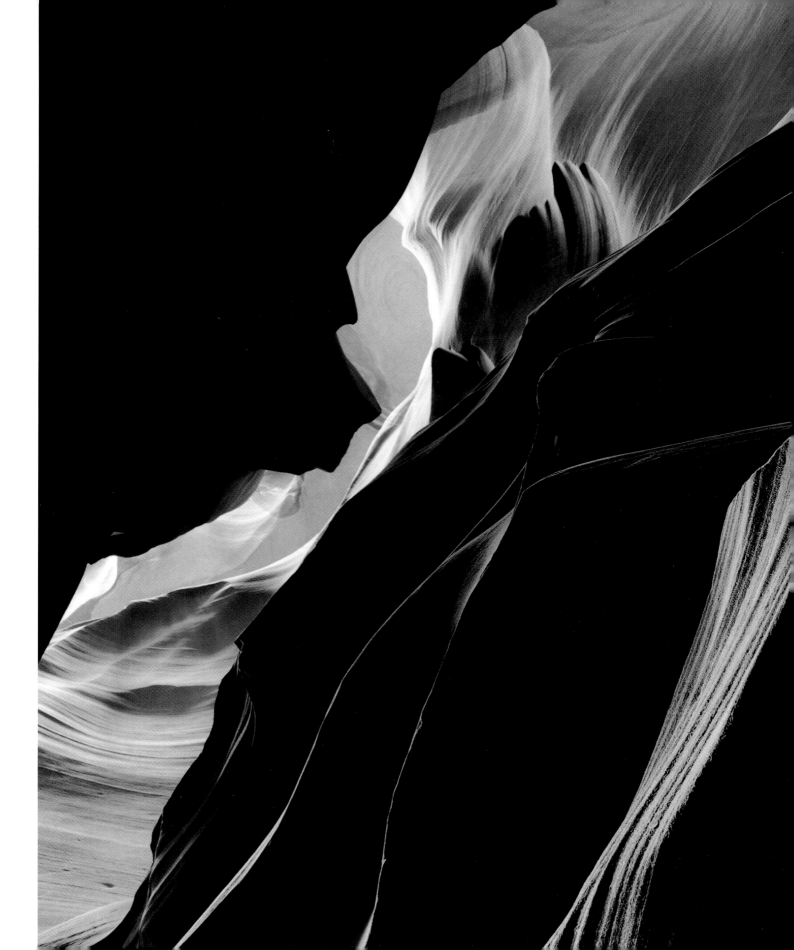

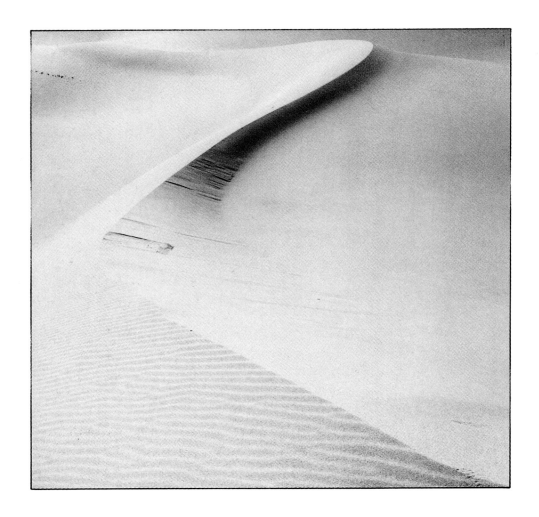

Tone, Texture and Contrast

Namib Desert I by Simon Norfolk
Mamiya 6 camera, 75mm lens, Tri-X film.
Exposure 1/2sec at f/22

The shape and the texture of these sand dunes I found
in the Namib Desert, an arid strip of inhospitable land that runs
down the western side of Namibia in southern Africa, fascinated
me. Because there were no living things in the scene to give the
picture scale, I had the freedom to play around and to explore the
design elements of this unique landscape through exploitation
of tones and shadows. I had a week in the area, and started
off by taking pictures that featured quite a wide angle of view
and were unnecessarily complicated. The more pictures I took,
however, the more I found myself simplifying things and paring
everything down to bare essentials, as I moved in closer and
closer to pick out the sometimes tiny areas of the scene that
worked the best. Some pictures, such as this one, featured just
one line and were virtually abstracts, and yet for me, these were
the ones that worked the best.

I decided that because the pictures I was shooting were so much
about tone, that I would give myself the chance when
I reached the printing stage, of achieving different effects.
Consequently I took six different frames of each scene, each
one shot through a different filter. I used an ultraviolet filter,
a Polariser, a red, an orange, a yellow and a light green. Each
gave a result that had particular qualities that I could exploit
in a print. This particular picture was shot through the orange
filter, causing the shadows which were reflecting the blue light
coming from the sky to go darker, while the orange colour
of the sand was lightened considerably.

Simon Norfolk

Technique This choice of viewpoint, coupled with the lightening effect of the orange
filter, has achieved a picture that has high-key qualities, i.e. a predominance of light
tones, which is particularly appropriate for a scene that is built around clean and simple
lines. The picture overleaf, taken at virtually the same time in the same location, shows
how much influence a photographer can exert over a scene through careful
composition and control of tones. The effect is completely different, though equally
striking.

Pointer Landscapes come in many shapes and forms and it's interesting to see
how it's the very lack of elements that has made this particular picture so effective.
Sometimes it's worth seeing if a scene can be simplified to telling effect: consider
every element that's included in your view and question whether it's necessary.
Closing in on just one fraction of a landscape can sometimes help you to isolate
the most interesting detail.

Tone, Texture and Contrast

Namib Desert II by Simon Norfolk
Mamiya 6x6cm, 75mm lens, Tri-X film.
Exposure 1 sec at f/22

I shot this picture in the Namib Desert in western Namibia just after sunset when the sky was still full of light, but the intensity had gone and the light was much softer. It's what's known as 'quiet light', and it lasts for just a few minutes, and during this time it's possible to take pictures that show this landscape looking incredibly smooth and soft. I love the tones that this light has produced: in the middle of the picture there are shades of grey within the grey itself and it almost looks like an airbrush finish. I used a yellow filter for this picture and this served to darken the tones of the sky and, because it was in shade and being lit by a light that had a blue bias, the sand also was rendered darker, producing a scene that was low key.

In this area sunrise and sunset are the only two times when it's possible to shoot landscapes: during the day there's an intense heat coupled with a slamming, vertical light that is impossible to work with. I stayed in a campsite that was about forty kilometres away, and I drove to this spot twice a day to take pictures. From the car I had to walk for around a mile across a flat plain to reach the dunes and then scramble a thousand feet up the side of the sand carrying all my kit to reach the vantage point I wanted, just about the most exhausting thing I've ever done.

It was quite a dangerous exercise because, once the light had gone, the whole area became pitch black and there was a chance of getting lost. I had to leave the headlights of my car switched on so that I could see where it was, otherwise I might never have found it again which, with the temperature plunging at night, would have been disastrous. I just hoped that when I got back to it the battery hadn't gone flat!

Simon Norfolk

Pointer Producing landscape pictures for his acclaimed project, 'For most of it I have no words', Simon Norfolk concentrated on areas around the world that had witnessed terrible events and yet somehow, still retained their beauty. The pictures in the Namib Desert marked the final piece of work in the project: 'There had been a massacre here early this century,' he says, 'when the country was a German colony. In a drive to clear the land for white cattle farmers some 80,000 members of the Herero tribe were driven into the desert and denied access to waterholes. It was the first genocide this century and it's largely been forgotten about by much of the world. By photographing the sand I was making a point about the selective nature of memory and how things get covered up eventually by time.'

Technique The choice of the 6x6cm format for the project was carefully thought through. 'The square format is classic,' says Simon, 'and I consider it to be one of the best and most natural ways of framing a landscape. It also is perceived by many people as a cool and factual format, which was exactly what I was looking for. I wanted to present my pictures and say to the viewer "This is where it happened", and for them to have to believe me.'

'Once the light had gone the whole area became pitch black: I had to leave the headlights of my car on so that I could see where it was.'

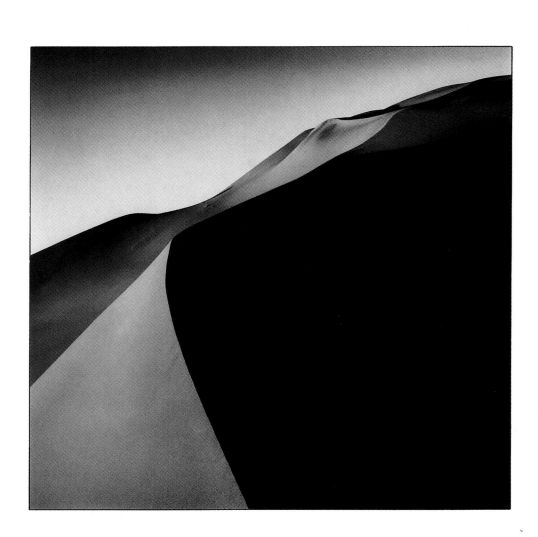

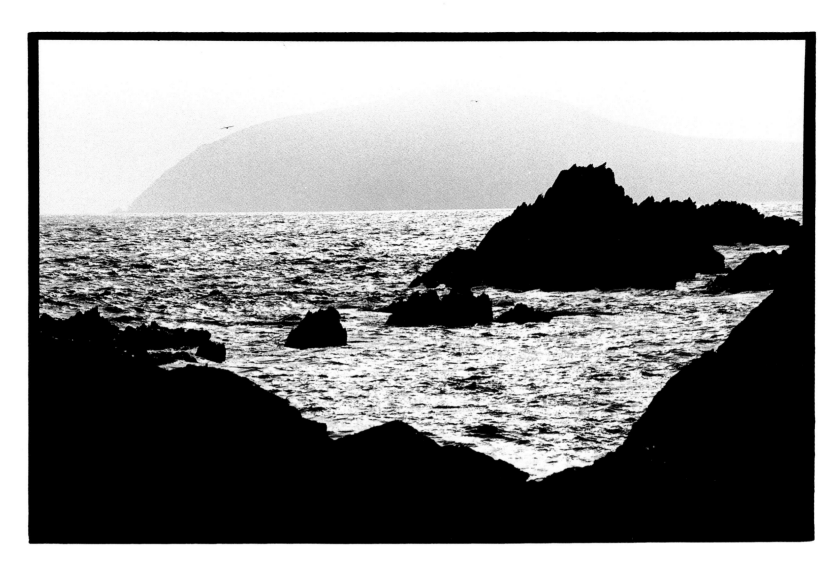

Tone, Texture and Contrast

Great Blasket Island Co. Kerry by Giles Norman
Nikon F70, 35–135mm zoom, Agfa APX 400 film.
Exposure unknown

If it's a bright sunny day then I'll invariably go to a location where I can photograph water. On land the heavy shadows that the sun throws can cause problems for landscape photographers, but over water the effect can be incredible, particularly if you break the so-called rules and look towards the light. That's what I did here for this picture of Great Blasket Island and the result is a picture that features enormous contrast. The shadow areas have become dark and impenetrable, while the highlights reflecting off the water have turned this area of the picture into a mass of glittering silver, where the texture of the water's surface has been revealed by the shadows between the waves.

Using this technique reduces a picture to its most basic elements, so to be successful you need to look for bold and dramatic shapes that you can include in the scene. On this particular day I headed for a beautiful location that I knew had the potential to offer me something special and simply walked along the rocks looking out for a suitable viewpoint. The zoom lens allowed me to play around with composition without continually having to alter my position and eventually I came up with a picture that includes the island, shrouded in haze, as a backdrop. For me the picture works because this allowed me to add a touch of mid-tone to off-set the dramatic contrast in the foreground. It's difficult to know at the time how things like this are working, because you won't know until you see your negatives exactly how the relationship between the shadows and highlights has developed, but this simply adds to the excitement of this kind of photography.

Giles Norman

Printing To highlight the contrast in the scene still further, the negative was printed onto a hard grade of printing paper. Normally a grade two will suffice for a negative of average density, but here grade four – usually called into action if the picture has been underexposed and is lacking contrast – was used. It's added extra punch by darkening down the blacks and brightening the whites, while at the same time ensuring no mid-tones remain in the foreground. It's also given a little extra tone to the island to allow it greater prominence in the picture.

Finishing Giles Norman always prints from his full negative and has a negative holder made for his enlarger that is slightly larger than the conventional 35mm size. This allows a thin strip of the clear film surrounding each negative to be included on all four sides, which gives a classic black border around the final print.

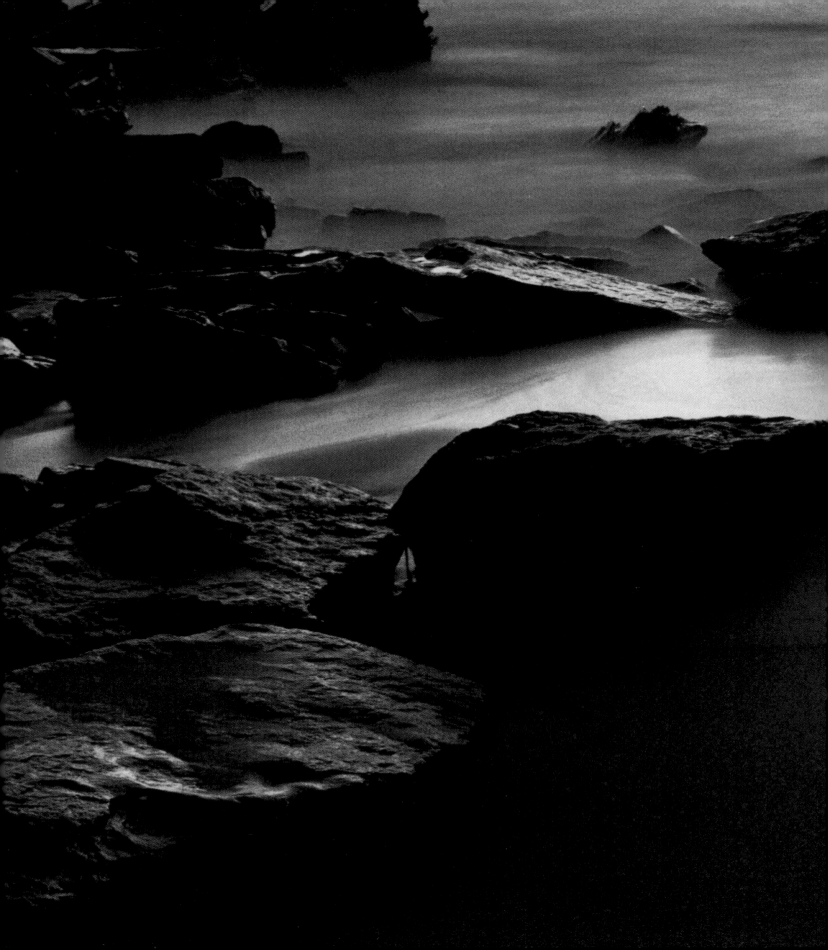

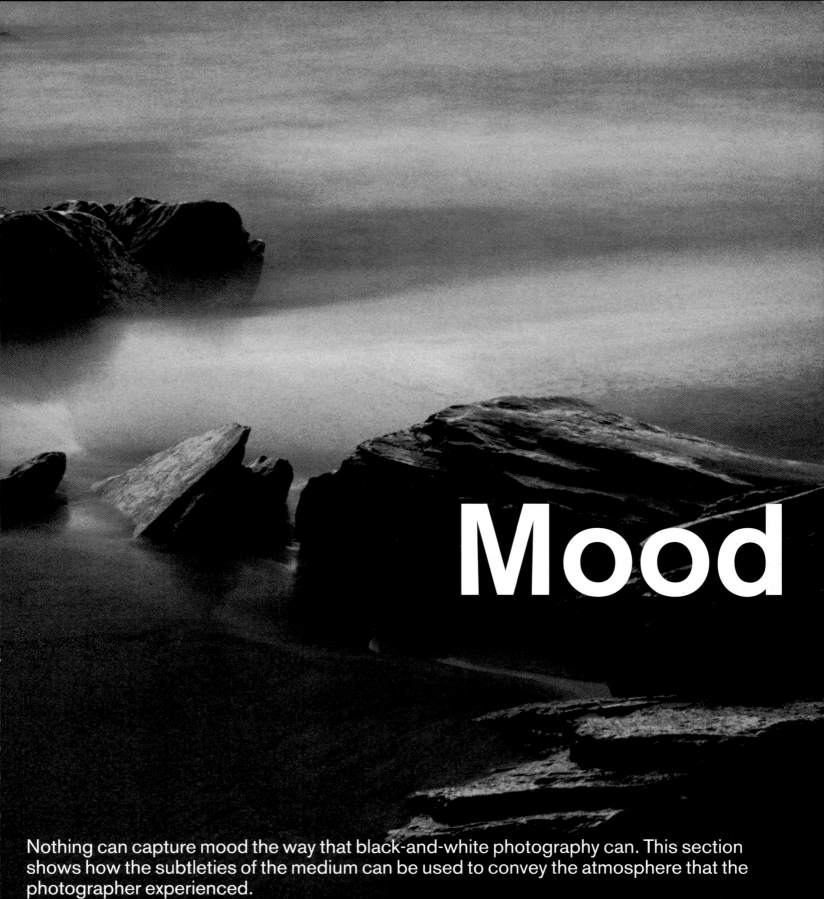

Mood

Nothing can capture mood the way that black-and-white photography can. This section shows how the subtleties of the medium can be used to convey the atmosphere that the photographer experienced.

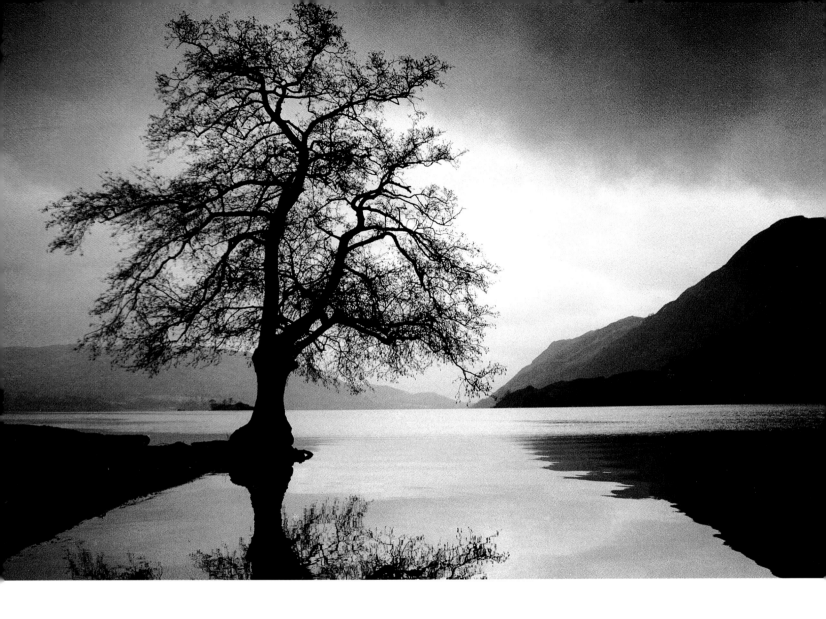

Mood

Silhouetted tree at Ullswater in Cumbria by Tom Richardson
Minolta X700, 28mm, Agfapan 100, orange filter.
Exposure 1/125sec at f/11

Natural silhouettes in landscape photography can be highly dramatic. I spotted this tree outlined against a bright sky as I was driving along the road that follows the shore of Ullswater in the Lake District, and I knew the contrast in this scene would make the basis of a great photograph.

It's very easy to get carried away when you see something like this, and to take the picture without considering carefully all the elements that have to be arranged properly for the picture to work. I spent some time looking at the scene through my viewfinder, and eventually decided that the silhouette would be cleaner and less cluttered if the whole tree were to be seen against the sky. From my obvious vantage point on the shore the lower branches would have been seen against the water, and so I needed to get my feet wet by moving right down onto the waterline to get down low enough for the view I wanted. I also managed to move into a position where the tree neatly filled the gap in between the two mountain ranges. It took some delicate manoeuvring and the only practical way I could carry this out was to hand-hold the camera, which ensured that 1/125sec was the minimum speed I needed to set to guarantee no camera shake.

This wasn't a particularly difficult shot to meter because there's equal areas of light and dark in the scene, and I went with the exposure that the camera's meter indicated. If anything, the brightness in the sky would have created a degree of underexposure and for silhouettes, this is no bad thing because it will ensure that shadow details are lost and that the contrast between light and dark areas becomes more pronounced.

Tom Richardson

My favourite tip The best time to use trees as a subject for a silhouette is obviously the winter, when the leaves have fallen and the intricate pattern of twigs and branches is fully revealed. But even then you'll find that not every tree is going to be suitable. My golden rule is that if you're going to use a tree as a focal point in your picture, then it has to be a good looking one. So many trees are not a perfect shape – they can have broken branches and scruffy elements within them. Take time to pick the right subject and you'll find that it will work much harder for you.

'I needed to get my feet wet by moving right down onto the waterline to get down low enough for the view I wanted.'

Mood

Gatehouse of Fleet, Galloway, Scotland by Tom Richardson
Minolta X700, 28mm, Agfapan APX 100, orange filter.
Exposure unknown

I love moody landscapes, and when my family took a holiday to Scotland I was determined to come back with something special. I didn't have to look far: we'd booked a cottage in a wild part of Galloway that had a drive leading to it that was about a mile in length, and this view could be seen from there. As a landscape photographer I knew all the ingredients were present: the water, the distant mountains and even the little detail of the fence in the foreground, everything was in place. But this was a scene that would only come to life with the right lighting, and I knew that as the sun rose in the morning it would appear in just the right position to take centre stage in the picture.

So I got up early every morning and took up position on the drive to wait for the sun to appear, and every morning the weather was poor and the picture didn't work. It was only as I took up my position yet again on the last day of the holiday that I sensed I was going to be in luck. The sky had clouds, but was relatively clear where the sun would appear and when it did, the sky was filled with the most beautiful colours. I thought that this was definitely a colour subject and took a whole film of the scene. Only at the end did I shoot a few pictures in black and white as a throwaway, using an orange filter to darken the sky down a little. When I got home and handed my films in for processing, disaster struck. The laboratory had an accident and ruined the lot and I thought that was the end of it. Around a month later I came across my black-and-white film of the sunrise, and there was just one negative that had really worked. I worked on it in the darkroom and this was the result: without a doubt a much better, and more atmospheric, picture than the colour version would ever have been.

Tom Richardson

Pointer It's not good news for those who like their lie ins, but the light that often accompanies daybreak is perhaps the best there is for landscape photographers, particularly those who like their results to be full of mood. The sun will be coming from a low angle at this time of day, and is weak enough to include as the focal point of the picture. It's also possible that there will be some mist around, particularly over water, to add an extra touch to the picture, something that won't be present at the end of the day when the sun goes down.

Printing Tom Richardson wanted his picture to have just a hint of a tone and so he adapted a standard blue toner kit to give him the effect he was after. Had he bleached the original black-and-white print back to the recommended level using full-strength bleach and then toned back, he would have achieved a result that was a vivid blue. Instead he printed dark initially and then treated the print in bleach that had been heavily diluted so that he had more control over the process. Then, when the print had bleached back to the level he wanted, he placed it in the toner for a reduced period, then washed and dried. The result is a blue/black finish that is subtle in the extreme.

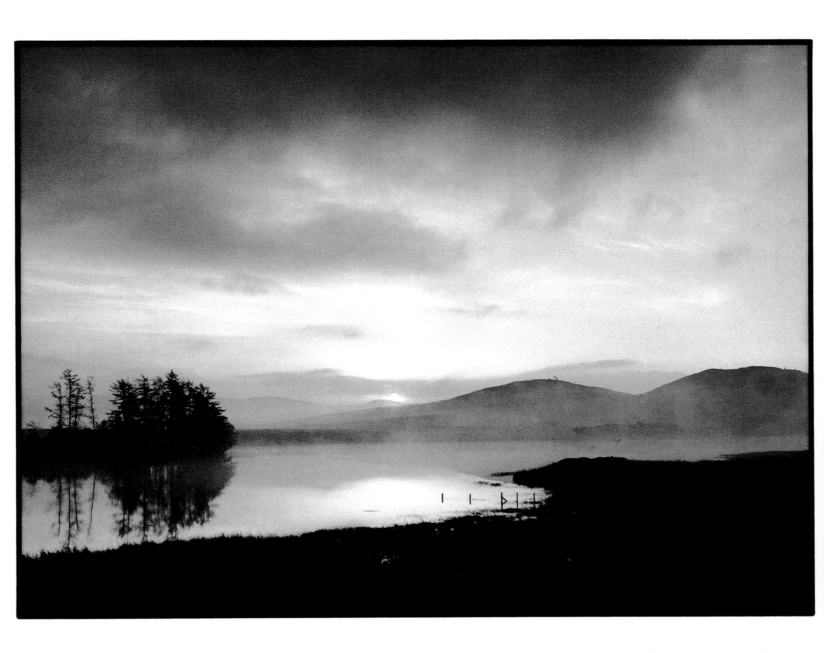

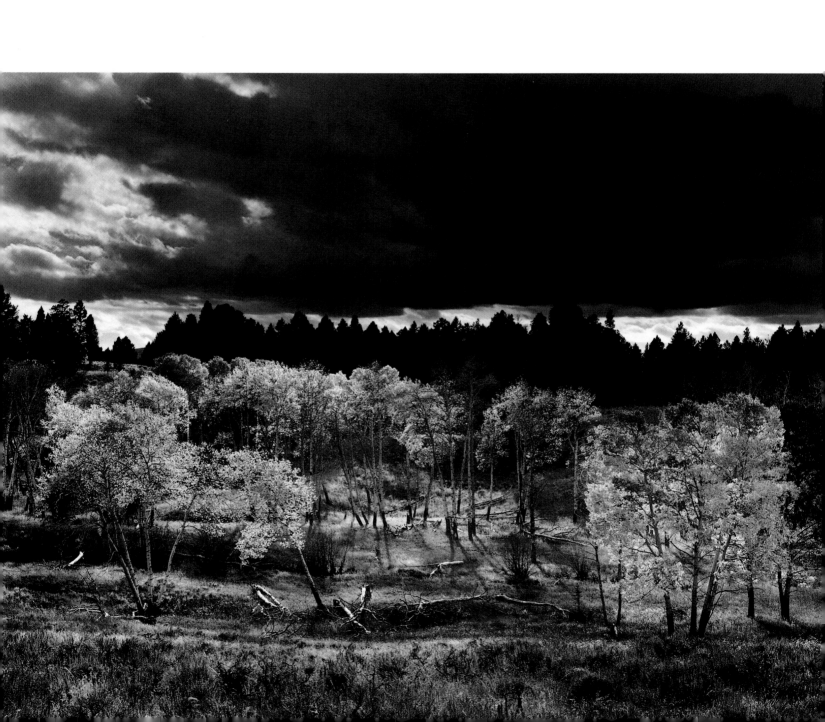

Mood

Aspens, Afternoon Thunderstorm, Wyoming by Bob Hudak
Wisner 5x4in field camera, 210mm lens, Ilford FP4 Plus film.
Exposure 1/15sec at f/22.5

There's no such thing as the right weather for landscape photography. Sometimes a sunny day can work, but often it's the times when the weather is less than perfect that you'll achieve something really special. It's impossible of course to know exactly when and where the best conditions are going to occur, but a landscape photographer should try to develop an instinct for a situation and know when it's likely to lead to conditions ideal for photography.

I came across this stand of aspens while I was on one of my trips out to the American west. I'd tried to photograph aspens before, but had never produced anything that I felt was particularly special, so I was determined to have another try on this expedition. When I first saw these particular trees the shape of them attracted me, but nothing else was really working.

The sun was hitting them from the front and making them look too flat and although there was a storm brewing, the sky wasn't that interesting when I arrived. I had the feeling that things might develop, however, and so I decided to set my camera up and to wait. Over a period of about an hour the sky gradually became darker and darker as the storm approached, but still the lighting was disappointing. Then suddenly the sun came through a gap in the clouds and hit the trees from behind. For about thirty seconds the lighting was amazing with the trees lit up against the threatening sky behind. I had time for one exposure and then it was gone: one sheet of film and that was it. Some days it just works!

Bob Hudak

Pointer The two keywords for all those hoping to master landscape photography are anticipation and patience. Sometimes, as here, the perfect situation exists for just a matter of seconds and if you're not ready to shoot – particularly if you're planning to use a sheet film camera that can take some time to set up – then you'll surely miss the moment. Even the best landscape photographers admit to a high failure rate, but it's only by taking the chance that something will happen and then being prepared to wait, that you'll achieve pictures as spectacular as this one.

Technique By using a yellow filter over his lens here, Bob Hudak was able to darken the sky down still further to increase the drama. A yellow filter transmits the green and red two-thirds of the spectrum and absorbs much of the remaining blue. This means that blue elements in the scene, such as the sky, will be darkened down considerably, while those that are green – vegetation and trees for example – will be lightened.

Mood

Mood

I spotted this moody scene while I was out walking in the Lake District with friends. It had been terrible weather all day and there were storm clouds all around: in fact England's highest peak, Scafell, is normally visible over to the right of the picture, but this day it was completely hidden from view. Even though the weather was so bad, there was the odd moment when the sun was creeping through and creating a brief scenario where the foreground was illuminated against the backdrop of clouds. As we approached a cluster of small stone-built peat stores, I could see that the sun was about to make another short appearance and so I stopped and got myself ready to take my picture. The use of a wide-angle lens made it viable to hand-hold my camera and as the sun hit the foreground, I managed to take three pictures in colour and three in black and white, and then the light was gone.

The scene ultimately worked far better in black and white, because I was able to enhance the mood that was already in the scene and to take it much further. Black and white gives you that control: you can play with a scene to suit your requirements, and I decided to make a sky that was already looking ominous into something that was hugely dark and threatening. This was the element that really gave this picture its power.

Tom Richardson

shaft of sunlight hits the building

the rest of the scene remains in shadow

Technique When the weather is dull, I keep an orange filter permanently attached to my lens because I find that this helps to increase the contrast of the scene. I metered here from the highlight areas and then gave a stop extra exposure to make sure that the light saturation I was getting in the foreground didn't lead to me losing detail in the shadow areas. At the printing stage I held back the foreground and gave the sky extra exposure to darken it right down and to achieve the moody feel I was after, and then finally the print was toned in thiocarbamide to achieve a finish that was a gentle brown. See page 123

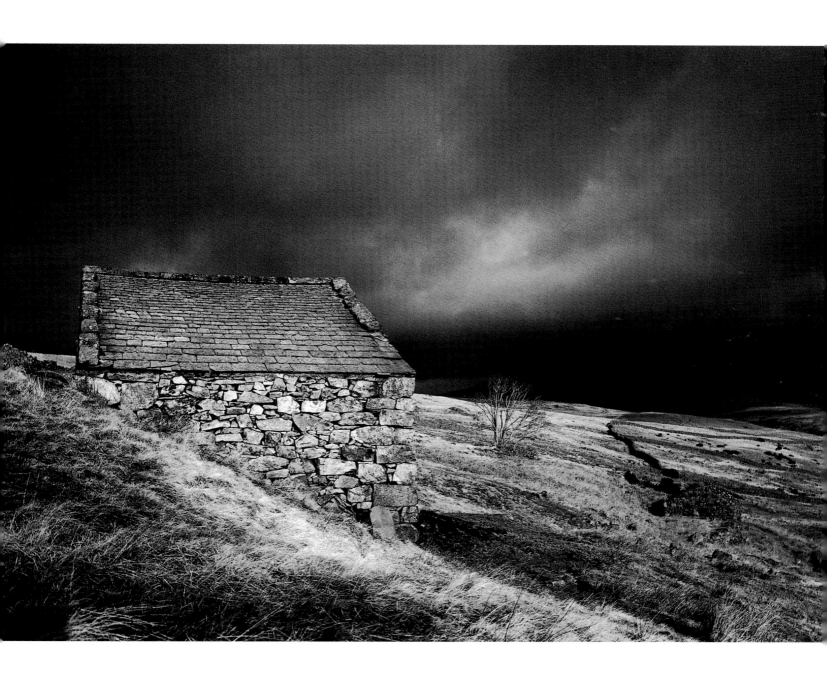

Mood

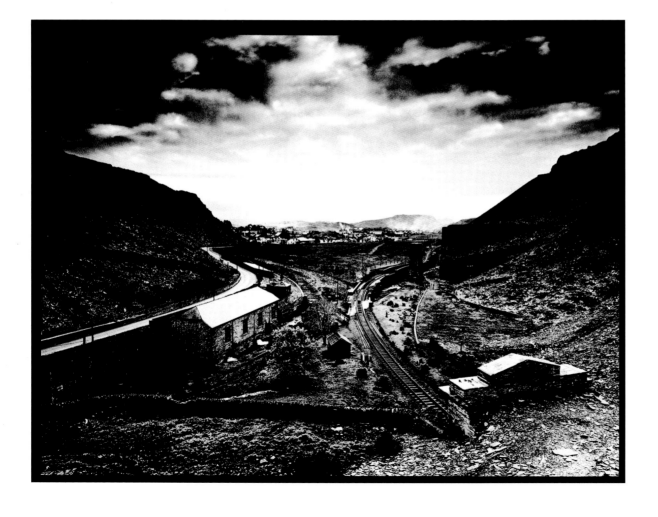

Slate Mining Town, Wales by John Claridge
Ebony 5x4in camera, 75mm lens, Agfa 100 film.
Exposure 1/30sec at f/22

This is a wonderfully dark and brooding industrial landscape, but then that's how I saw it. The mood and the atmosphere was already here, and all I've done is to emphasise it through the use of black-and-white film. Apart from a little extra drama created by printing down the sky and the tops of the mountains, this is how it was.

There are obvious things that attract you when you go looking for a landscape picture. Here I was taken by the graceful and contrasting sweeps of the railway and the road, heading off in opposite directions but both appearing to lead to nowhere. They complement the rather bleak nature of the picture and are essential elements of the composition.

It's a hard landscape there's no question of that, and that attracted me as well. It's not beautiful in the conventional sense, but it has its own strength and character. I love industrial landscapes such as this one: they contain a lot of ghosts, in the shape of the mark that's been left on the land by the attentions of man. You get the smell of what once happened here and you know in your heart that it will never happen ever again.

It will all soon change as the supermarkets and the fast-food stores turn up and clutter the view, but at the moment it has a certain magnificence about it. I think it would be a lot easier to write a piece of poetry about a landscape such as this one than it would be to write about the more obviously beautiful locations.

John Claridge

Pointer Shooting this picture under bright sunny conditions would have been fruitless. The idea was to convey a mood of decay and this could only be done effectively if the conditions were suitably sombre. The scene is backlit from an overcast sky and the soft directional light this is throwing has reflected off the roof of the building on the left and the top of the tunnel portal, adding form to these structures and giving depth to the picture. Slate is a naturally reflective material and shooting in the aftermath of a shower would increase this property, adding a sheen to the landscape that lifts the contrast of the picture.

Composition Look for strong lines, natural or man-made, that will lead the eye into the picture. Here John Claridge has utilised the graceful sweep of a road and a railway line to great effect. The use of a wide-angle lens to include as much of both of these in the foreground as possible has heightened their impact, and strengthened the composition.

'I love industrial landscapes: they contain a lot of ghosts, in the shape of the mark that's been left on the land by the attentions of man.'

Mood

Mood

Clogher Strand and Head, Dingle Peninsular, Eire by George Jackson
Minolta X300, 28mm, FP4 film.
Exposure 5mins at f/16

When I first visited this location in western Ireland I had a camera loaded with colour film and, although the results were not bad, I knew that the potential was there to capture something more. I felt that I would achieve a much better sense of the mood of this beautiful and lonely place if I went back and shot using black-and-white film. When I finally managed a return visit, I travelled to the location every night as dusk fell to see if the conditions were right for photography. It was a question of the tide and the sky combining in just the right way and eventually, after persevering for a few days, everything fell into place.

I wanted to use as long an exposure as possible to allow the water to move and to be completely soft and blurred on the film and as there was still quite a lot of light around as I started to shoot, I fitted a neutral density filter to the lens. This cut down the amount of light reaching the film and in combination with a small aperture of f/16, it allowed me to bracket my exposures at thirty seconds, one minute and two minutes. As the light continued to drop, I was able to go slower still and eventually, I was bracketing at one minute, two minutes, five minutes and ten minutes. This picture was produced using a five-minute exposure, but most of the negatives I obtained that evening can be printed with a little care, the low light I was using and the latitude of the film combining to ensure that exposure time wasn't critical.

I had a period of around half an hour to work within, which gave me plenty of time to get the pictures I wanted. I'd pre-visualised the scene I wanted and it worked out almost exactly how I had expected.

George Jackson

My favourite tip I've got together with two other photographers to run a market stall once every two weeks and we use it to sell signed prints to the public. It's a really good informal way of showing work and usually we end up selling something to make the day worthwhile. I price my prints at £25 for a 10x8in, £35 for a 10x12in and £50 for a 20x16in, which is within the range of people who happen to see a print which they like and gives me a small profit as well.

Technique The extremely long exposures that were being given ensured that great care had to be taken to make sure that camera shake didn't occur. Here the camera and tripod was placed on a solid platform of rock to ensure that it remained steady throughout the exposure and the shutter was fired by using a cable release to minimise vibration. Other tips for keeping the camera steady include flipping the mirror up before pressing the shutter and weighing down the tripod with sandbags or rocks tied to pieces of rope to ensure it's wind resistant.

Mood

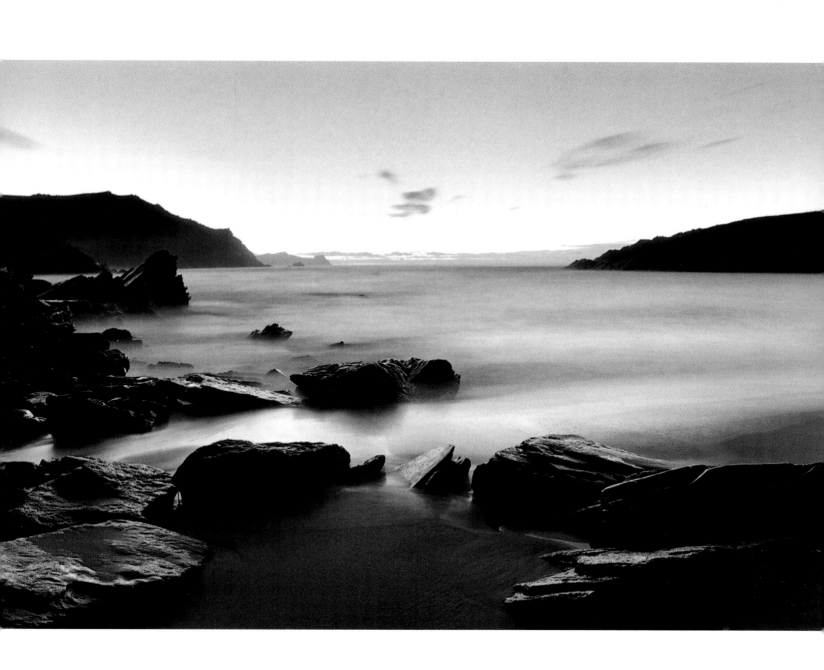

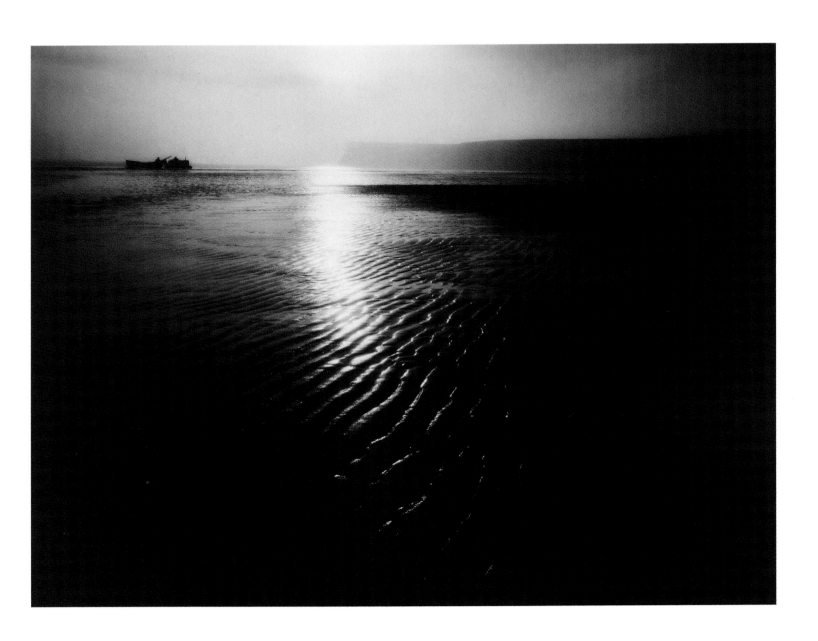

Mood

Tractor and Beach, Yorkshire by John Claridge
Ebony 5x4in camera, 75mm lens, Agfa 100 film.
Exposure 1/15sec at f/8

You always have more chance of finding mood in a landscape if you go looking for pictures at the times of the day when the light is at its most atmospheric. Early morning is a favourite time of mine, as you never quite know what you're going to find. Sometimes you come back with nothing at all, but at other times it can be magical.

On this particular occasion I was visiting Yorkshire while shooting pictures for a brewery's annual report. I decided to get up very early one morning and to head for the beach with my 5x4in camera to see if there was anything there worth photographing. When I arrived it was still virtually dark, and the sun was just about to rise through a mass of cloud cover. The whole scene was very, very quiet and the tide was completely out, exposing the ripple marks on the sand.

There still wasn't enough to make a picture, however, and then I got lucky, because I saw a tractor in the distance that was dragging a boat back from the edge of the water. It was the perfect extra detail that made the whole scene come to life. I used a wide-angle lens to emphasise the ripple marks in the foreground and to make the tractor and its load appear tiny on the horizon. The lens also helped to ensure that everything was in focus, from the foreground right through to the background, and it helped to give great depth to the picture. Not only was it a picture that I enjoyed taking for myself but, because it showed something of the environment in the area where the brewery was based, it ended up being used in the annual report as well.

John Claridge

Pointer The reflective qualities of water can add an extra dimension to a landscape picture. Had the wet sand not been so dominant in the foreground here, the line of light thrown by the rising sun, which is such a vital part of the whole composition, wouldn't have been picked out so clearly. A similar effect can be found just after or even during, a rainstorm, when non-absorbent surfaces such as rock will take on a sheen that can be used as an extra element in a landscape study. It's a good reason not to be put off by poor weather conditions: landscape photography is seldom best undertaken on a dry sunny day.

Texture The ripple marks in the wet sand are key to the success of this landscape and yet lighting coming from a different angle would have made them virtually disappear. By looking directly into a rising sun, John Claridge has utilised the ideal lighting set-up for his picture: the low position of the light source has skimmed the surface of the sand and created dense shadows in between the ripple marks, effectively highlighting them and revealing their texture. Later in the morning the sun would have taken up a position much higher in the sky and the lighting would have been much flatter, disguising the form of the sand and taking away a major element of the picture.

Landscape has a habit of delivering the unexpected and when you come across something, you have to be prepared to make the most of what you find. This was a picture taken in the early morning, which I've always found to be the best time of all for landscape photography because of the subtle and beautiful lighting conditions you can get at this time. I was driving along a route that took me by the shore of Halje Fjord and simply saw this scene from the road; it looked beautiful and I knew I had to stop and try to make something out of it. Many of the best landscape pictures I've taken have originated in this spur of the moment way. On this occasion, the mist was rolling in from the mountains and removing much of the detail in the scene to great effect, taking everything down to the most basic elements. I took just one picture, hand-holding the camera for the exposure of 1/125sec and this, with a little judicious cropping top and bottom, is the result. It's an exercise in simplicity, where less has definitely become more. The reflections I achieved on this still morning added the final telling touch to what was a very quickly conceived and executed picture.

I would say that the best lesson a landscape photographer can learn is to have an eye for a picture all the time, because the best situations are seldom predicted. I've been looking in one direction for a picture and have turned around to find that the true photograph has been created by the lighting conditions behind me. I've also taken pictures whose worth has never struck me at the time, but which I can recognise as worthwhile images only when I see the contact sheet. Sometimes we can surprise ourselves long after we've pressed the shutter.

Michael Trevillion

Mood

Halje Fjord, Norway by Michael Trevillion
Pentax 6x7cm, 55mm lens, Kodak Plus X ISO 125 film.
Exposure 1/125sec at f/8

Composition This composition works largely because of the symmetry that's been created through the reflections on the water's still surface. By choosing to keep his horizon dead in the centre of the picture, Mike Trevillion has allowed these to be emphasised, while placing the boat so prominently in the right foreground has added an essential detail that has saved the picture from becoming too bland. If you use your hand to shield the boat, then the impact of this delicate landscape is lost instantly: on such details does the success or otherwise of a landscape picture often depend.

Pointer The traditional advice about always keeping a camera close to hand still holds good, particularly with landscape photography which relies so heavily on what may be transient lighting or atmospheric conditions. With modern compact cameras and films offering such enormous quality these days, even a cheap camera tucked in the glove compartment during a long drive can save the day on occasion.

'The reflections I achieved on this still morning added the final touch to what was a very quickly conceived and executed picture.'

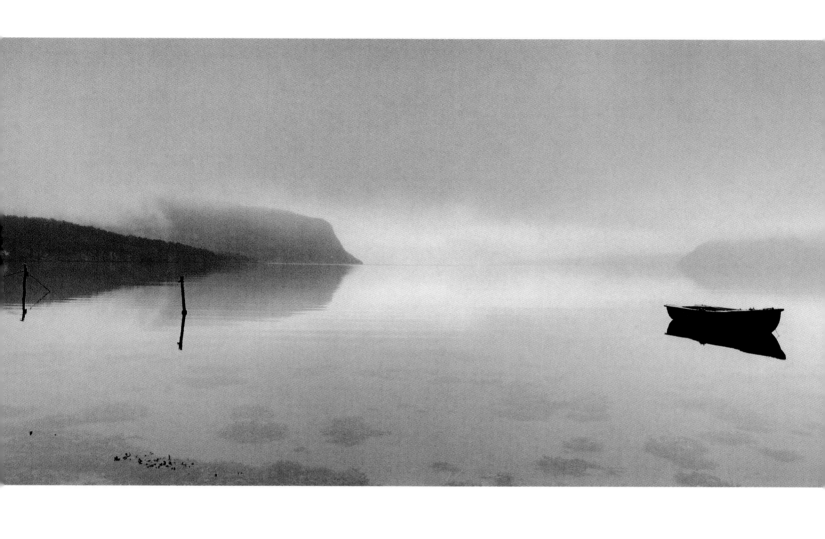

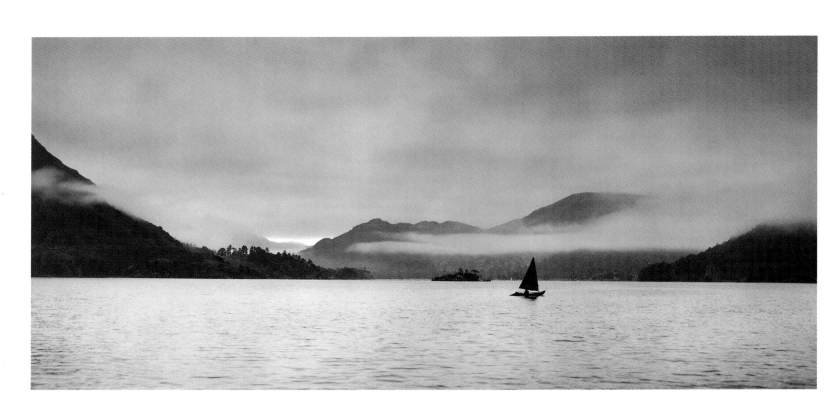

Mood

Cumbria 1991 by John Swannell
Linhof 6x12cm, 65mm lens, Agfa APX 25 film.
Exposure 1/60sec at f/16

There's no light like early morning light for landscape photography. It's by far the best there is, because it's subtle and moody and if you're in an area like Ullswater in the Lake District where there are a lot of mountains, there's always the chance of encountering something extra at that time of day. When I arrived at this location at 6am there was mist and low cloud clinging to the landscape around the lake, with just one small patch of brightness in the sky in the middle distance. I was able to use all these elements in the picture I took.

Although I shoot a lot of landscapes purely for my own pleasure, this one was produced as part of a commercial shoot I undertook for a hotel chain. The client wanted to feature a boat on the lake, so the art director for the shoot brought his inflatable with him on the roof of his car and was duly dispatched out onto the water to become part of the scene. We communicated through walkie-talkies and I directed him precisely to the area I wanted him to be. Because it was so early, his was the only boat around and consequently this was one element of the picture that I was able to control, although obviously pretty much everything else was out of my hands.

Because shooting landscapes can be such a lottery, we gave ourselves a couple of days to make sure that we could have another try if things didn't work out. As it turned out, however, everything went perfectly on the first morning and the extra time wasn't necessary.

John Swannell

Pointer The 6x12cm format is my favourite for landscapes, because I consider that it produces the nearest approximation to the way we see with our eyes. We don't, for example, see in square format while a full-blown panoramic format such as 6x17cm is too wide. But if you split this picture in two so that you're seeing the left-hand side with the left eye and the right-hand side with the right eye, then you'll see that the perspective you're getting feels really natural.

My favourite tip I always bracket my pictures two stops either side of the reading my meter gives me, because that way I cover myself in terms of achieving the perfect exposure. There's also a bonus in that through looking at contact prints of the pictures that are underexposed, I'll be able to see if there's likely to be anything in the sky that can be printed in on one of the more dense negatives.

Mood

The Haunted Wood by Michael Trevillion
Olympus OM1, 28mm lens, Kodak infrared film.
Exposure 1/125sec at f/11

I had been asked by a publisher to produce a picture for
the front cover of a book, and they wanted something that was
full of mood and which summed up in a visual way the idea of
being chased through a spooky-looking wood. Choosing the
New Forest in Hampshire as a location, I travelled there with my
camera and started to look around for ideas. Nothing seemed to
work, because everywhere just looked too pretty, more suitable
for a chocolate box cover and for a while I was struggling.

The problem was solved, however, by loading an infrared
film into the camera, which gave me heavy grain alongside
tones that glowed and were strikingly different to those that
conventional film would deliver. In addition, I smeared generous
amounts of petroleum jelly over the front element of the lens,
which created localised areas of diffusion and added enormously
to the surreal, rather alarming, look that I was getting. I loved
what I was seeing through the viewfinder and there was endless
room for experiment. Simply smearing the coating of jelly around
created all kinds of different effects and I genuinely had no idea
exactly what I was going to end up with, which was an exciting
way to work.

Finally the picture was printed onto lith paper, which added
contrast and gave the whole image a characteristic pink tone. I'd
created a surreal and mystical scene from what was an everyday
location, and the publisher was delighted.

As for the lens, I cleaned it up carefully and it survived the
experience with no ill effects. I feel that people are often too
precious about the way they treat their cameras: the OM1
cameras I use are excellent, but they don't cost a fortune. I work
them hard and then change them every few years.

Michael Trevillion

Pointer I'm almost anti-technique in the way that I work: I hardly know anything about
the technical aspects of photography at all, preferring instead to shoot by instinct and
to learn from mistakes. When I'm producing pictures for book covers I always travel
light, because this gives me the ultimate freedom to look for things that are interesting. I
don't take lights and I usually work with 35mm because any grain that results simply
adds to the effect and is invariably loved by the clients that I work for.

Tone, Texture and Contrast This surreal picture only works because of the strong
directional lighting that the scene was receiving. It's highlighted the slender trunks
of the trees in the background and most importantly, created dappled patches of
brightness among the shadows on the forest floor. A dull day would have taken away
all this essential contrast, and would have left Mike Trevillion with nothing with which to
create foreground interest.

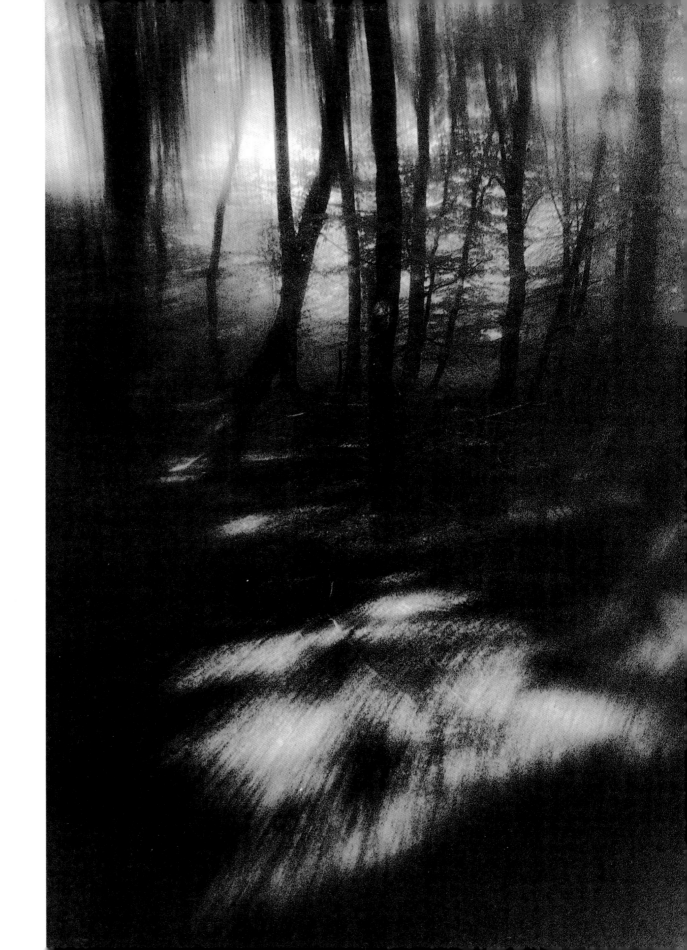

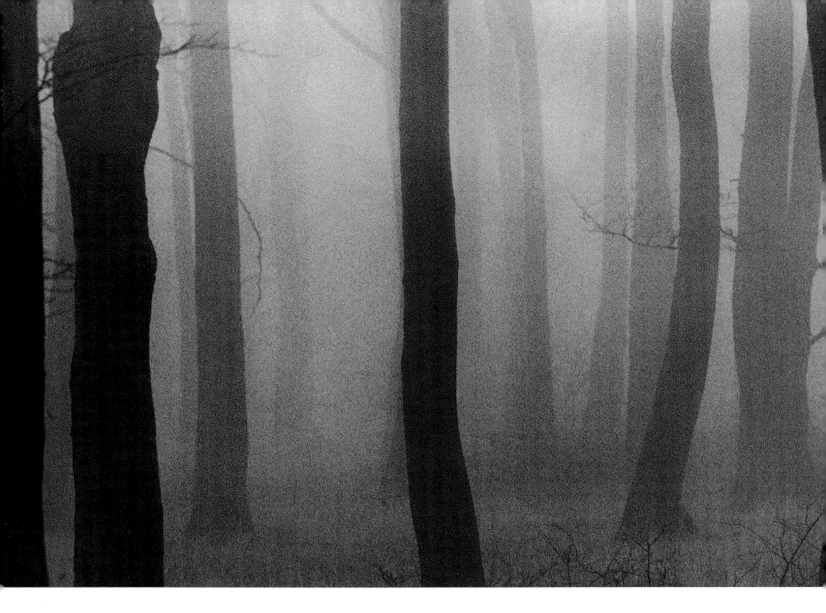

This was taken in a wood that's close to my home in East Riding, Yorkshire. For me, landscape photography only really becomes possible when I know an area really well. I walked around these woods, which are part of a private estate, for years before I took any pictures. Now I take the camera with me when I'm exercising my dog and if I lose the dog for a while it gives me time to take some pictures!

I find this kind of intimate knowledge about a location allows me to understand its many moods and it's remarkable how different a place can look as lighting or climatic conditions change, or as the various seasons make themselves felt. The effect of mist is particularly dramatic, especially in terms of the influence it will have on the tones of a picture.

When I came across this scene, I pondered how to do justice to what I was seeing. As a printer I've learned that balance is really important in a picture, so I composed this image in such a way that the trees closest to the camera, which featured the darkest tones, formed a solid edge down the right and left hand sides of the image. This served to give the whole picture a frame within which to work.

Adrian Ensor

Mood

Early Morning Mist by Adrian Ensor
Nikkormat 35mm SLR, 35mm f/2.8 lens and orange filter,
Ilford HP5 rated at ISO 320.
Exposure 1/125sec at f/11

Printing This was a fairly straight print that was subsequently toned in thiocarbamide. This is a particularly versatile two-stage toning treatment that depending on the ratio of the toner/activator mix, can give you a final print tone that ranges from yellow brown (less activator) to purple brown (more activator). You can also influence the final tone of the print through varying the initial bleach timing or concentration. This is where experimentation comes in, but remember to keep a record so that you can repeat the results you find most pleasing. I also very lightly gold-toned the print finally to ensure that it didn't veer too far towards yellow.

Technique I downrated the Ilford HP5 film I was using from ISO 400 to 320 to ensure that the negative leaned a little towards minor overexposure rather than underexposure. It's a little extra compensation for the use of the orange filter and it helps to give me a negative that I find easier to print.

Mood

Mount Vision Moonrise by Marty Knapp
Canon F1, 85mm lens, Kodak ISO 25 Technical Pan film.
Exposure 1/8sec at f/16

Including the moon in a landscape picture isn't easy. It takes a certain amount of luck and perseverance, but it is perfectly possible by using astronomical charts or referring to specialist websites, to predict exactly where the moon will rise on any given night anywhere in the world. Armed with this knowledge you can at least undertake a certain amount of preparation. This was how I knew that the moon would rise in this position over Black Mountain, so I set out for a vantage point on Mount Vision that I knew about with the idea of taking this picture. The first time I tried I wasn't successful because the moon didn't attain the necessary contrast until it was so high in the sky that it had no relationship with the land. The following night I tried again and this time there was a heavy fog. I thought about turning back but carried on, more in hope than expectation, and then suddenly, just over the last one hundred feet of the climb, I came out into clear air.

There was about twenty minutes to go before the moonrise and I knew that conditions would be perfect. The moon stood out against a darkening sky, but there was still just enough light on the distant hills for some detail to be picked out there, which was vital. The foreground was in shadow and became virtually a silhouette, while the mist hanging in the valley below added greatly to the mood. It was one of those rare occasions where all the elements came together and it gave me a remarkable picture.

Marty Knapp

Printing and Processing This is probably my hardest negative to print because there are so many different areas of the picture to be aware of. I want the foreground to be dark impenetrable shadow, the fog to have luminosity and the ridge of mountains behind to have detail in them. Then there's the sky and the moon: the sky needs to appear dark to act as a contrast to the moon, while the moon itself has to feature detail, but can't be allowed to go too dark. I start the print with one overall exposure and this is all that the bottom half of the print receives. Then I use a piece of card to give extra exposure to the top half of the picture in a series of steps, taking care to keep it moving at all times so that no noticeable bands of density are created. I use a metronome to help me judge the timing and I know through experience that I need to give two to three beats in certain areas to achieve the correct print exposure.

Websites It's become far easier to find out where the moon will rise any given day since the growth of the Internet. At http://aa.usno.navy.mil/aa/data/docs/altaz.html you'll be able to find the information you require for any location in the world, so it's now far easier than when I started out using astronomical charts to work out the moon's position.

I've found that my own website, which is located at http://www.martyknapp.com, has worked as an excellent support mechanism for me. If I receive a call to the studio asking for a catalogue, I can refer people directly to this address and this then becomes a simple way of allowing them to browse at their leisure through an extensive selection of my work.

'The moon stood out against a darkening sky, but there was still enough light on the distant hills for some detail to be picked out there.'

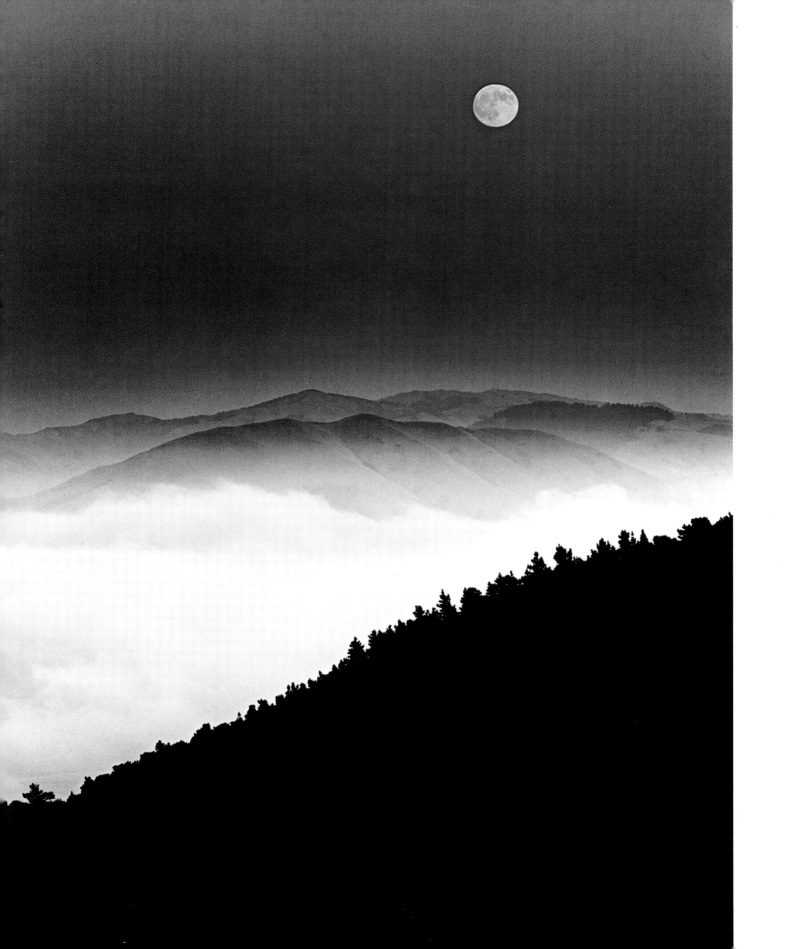

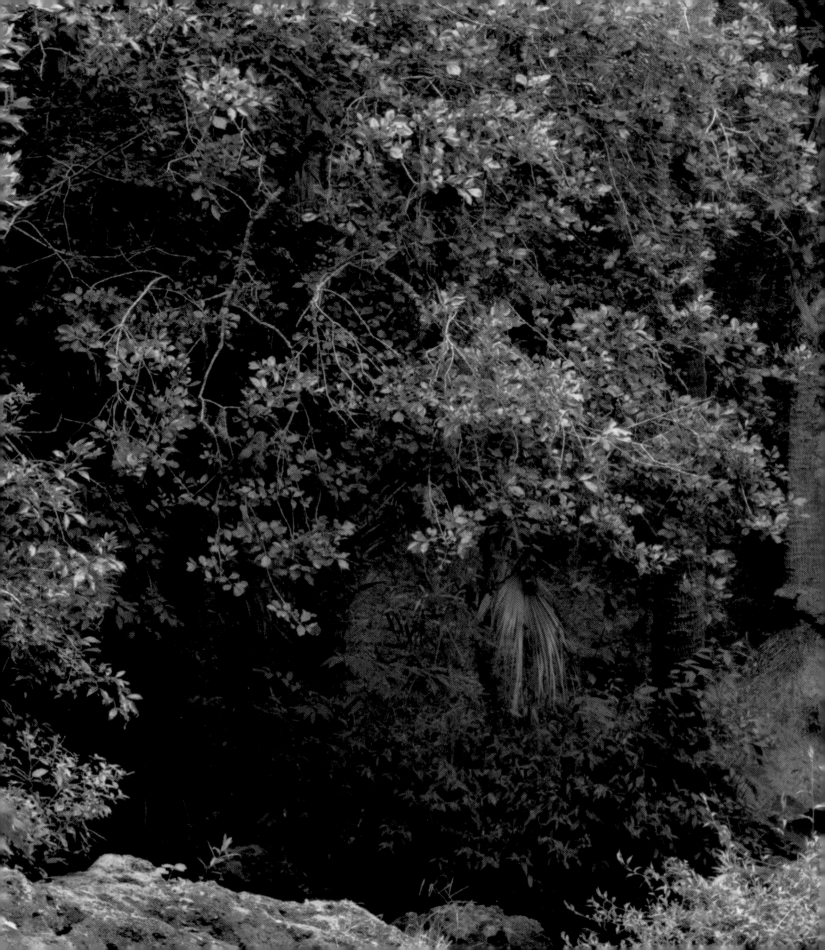

Gallery

It's time for a treat. Sit back and enjoy this collection of wonderful pictures, from a selection of great landscape photographers.

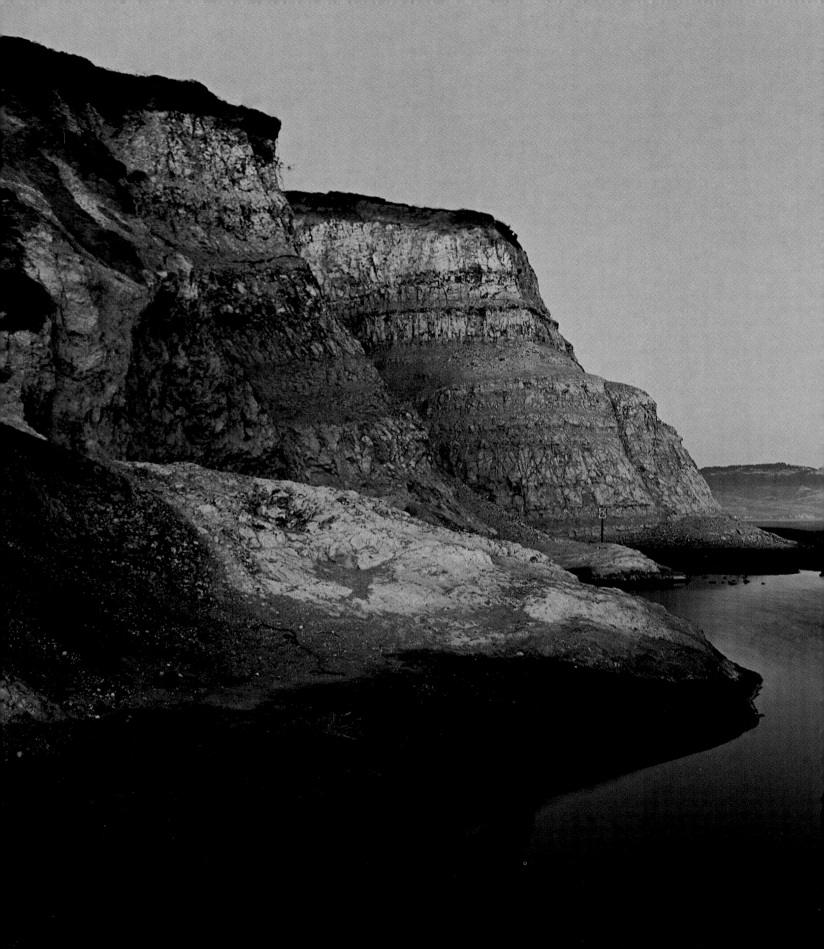

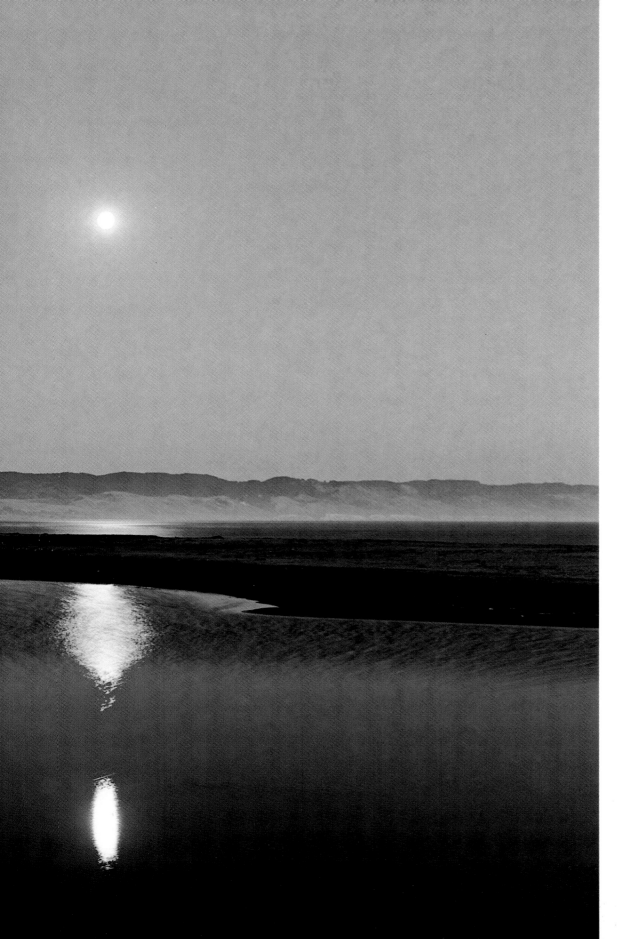

Reflecting Moon, Point Reyes National
Seashore, California by Marty Knapp
Mamiya 1000S 645 camera, 55mm Sekor lens,
Kodak Technical Pan film, ISO 25.
Exposure 1/8sec at f/22

Nude in Landscape by Michael Trevillion
Pentax 6x7, 55mm lens, Ilford Pan F ISO 50 film.
Exposure 8secs at f/22

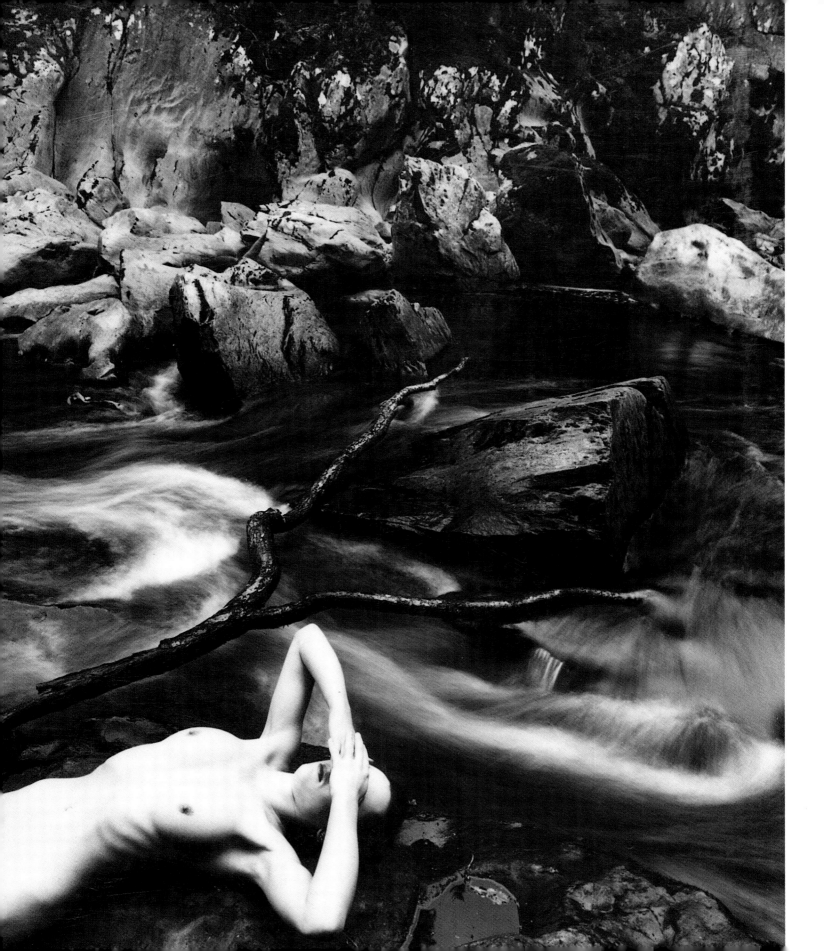

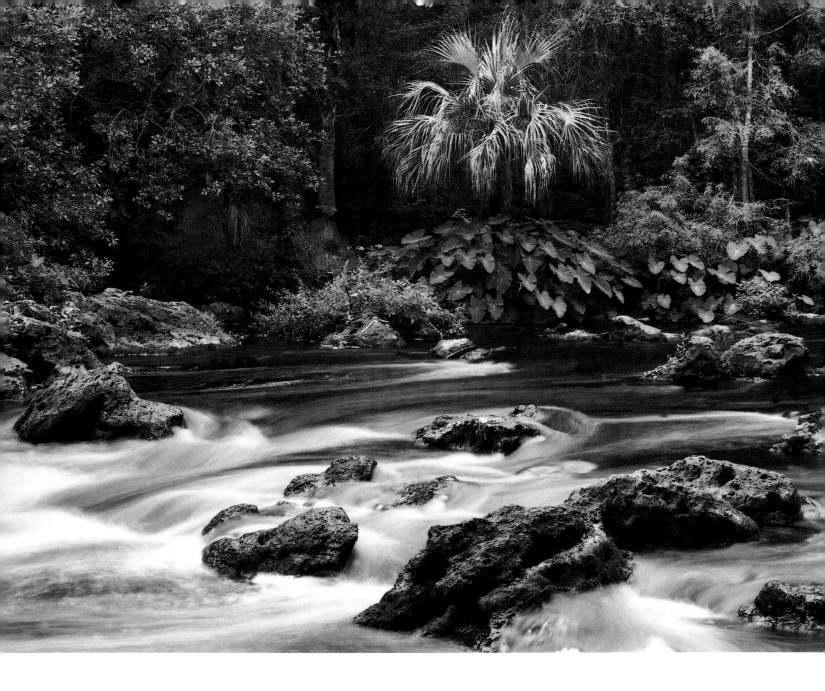

Hillsborough River at Dusk, Florida 1994 by Bob Hudak
Wisner 5x4in field camera, 210mm lens, Ilford FP4 ISO 125 film.
Exposure 1sec at f/22

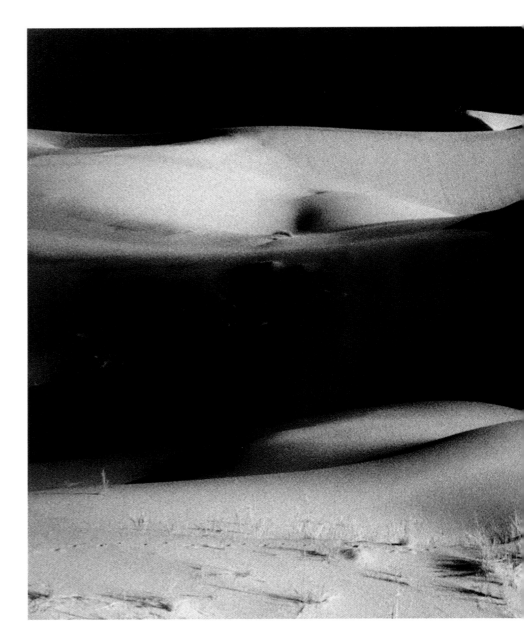

Lone Tree in the Sahara Desert by Michael Trevillion
Olympus OM1, 28mm lens, Kodak infrared film.
Exposure 1/125sec at f16

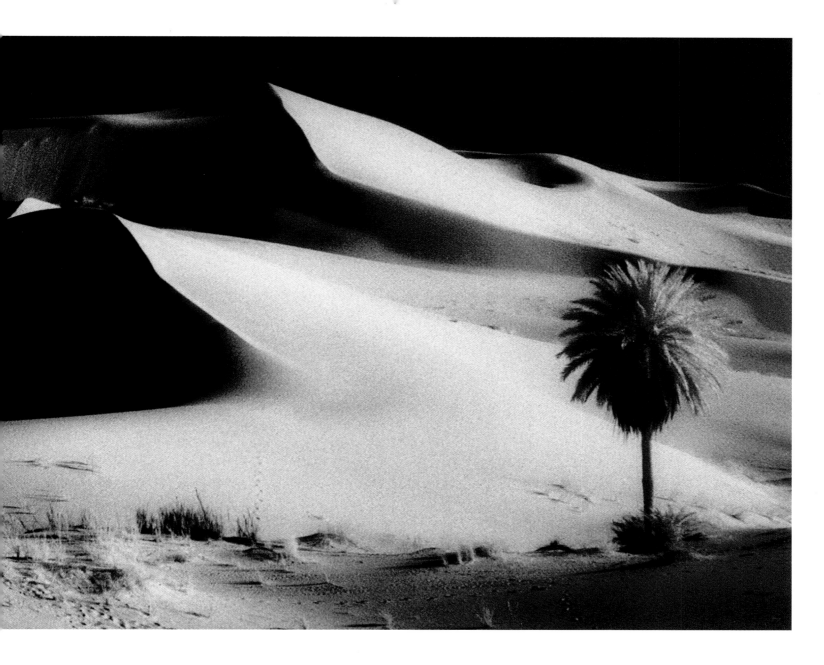

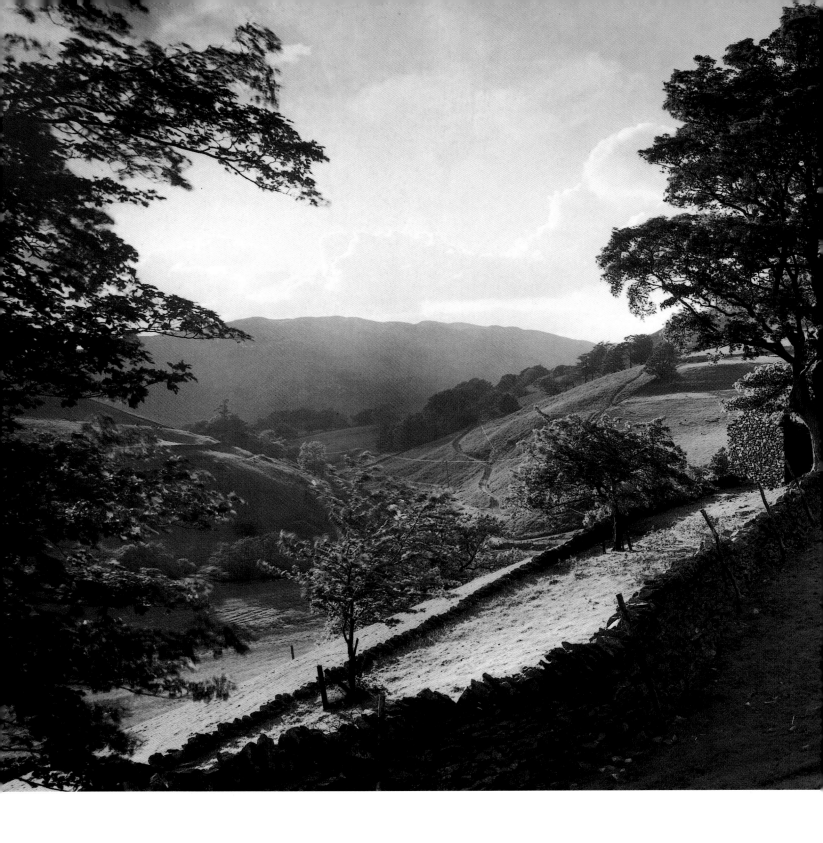

Cumbria 1994 by John Swannell
Linhof 6x12cm, 65mm lens, Agfa APX 25 film.
Exposure 1sec at f/22

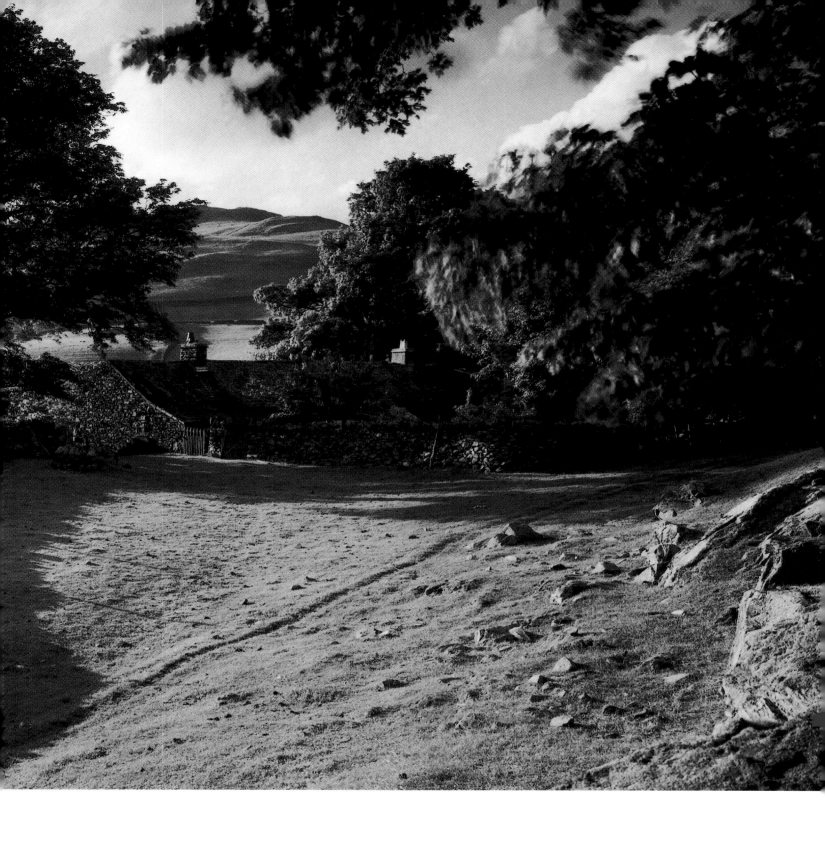

Gallery

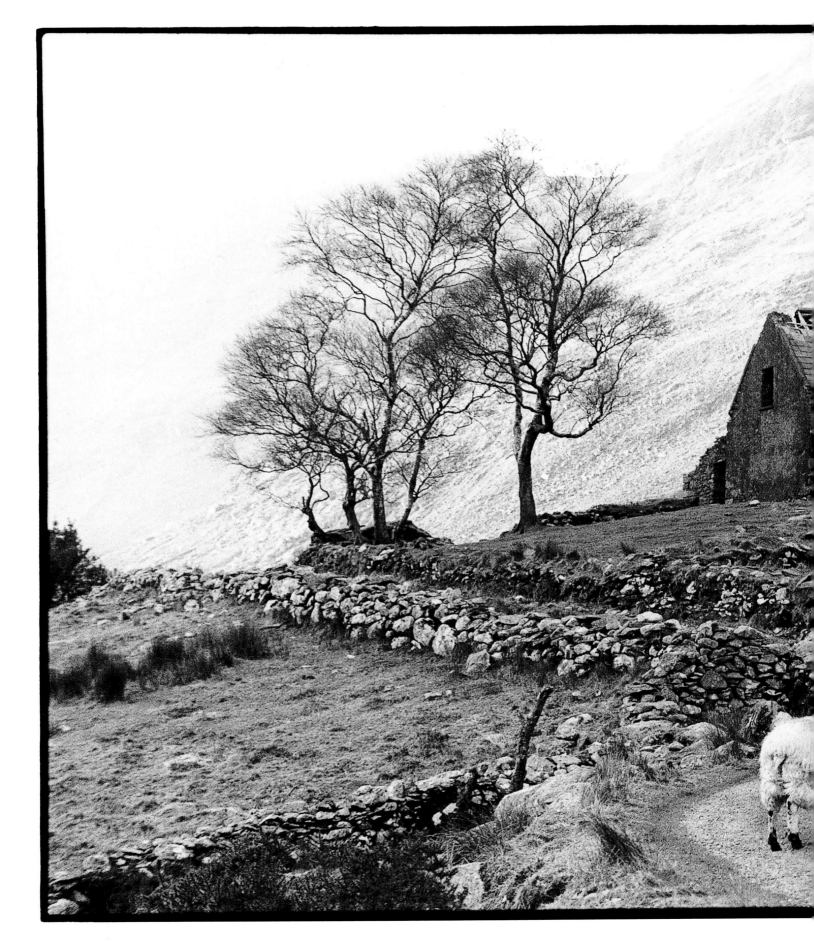

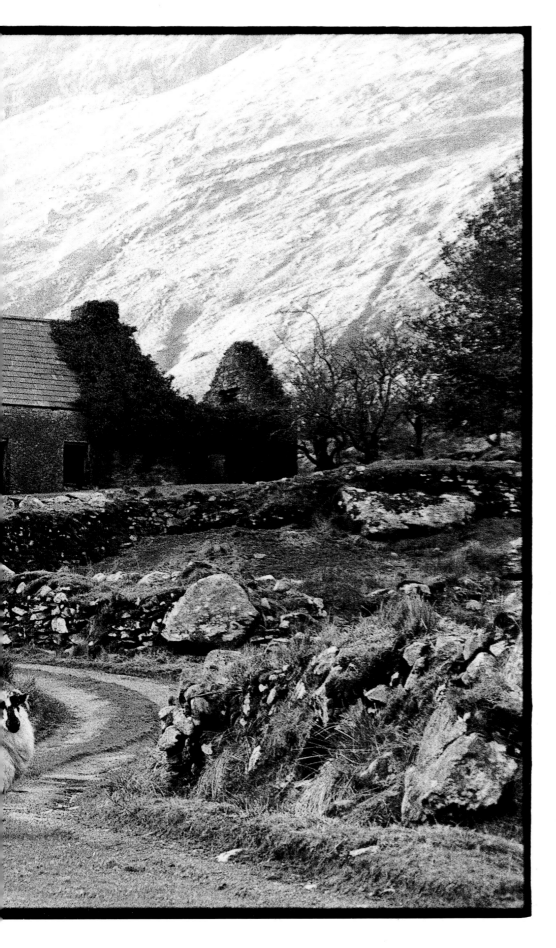

Sheep and trees, Co. Kerry 1994 by Giles Norman
Nikon F70, 35–135mm zoom, Agfa APX 400 film.
Exposure unknown

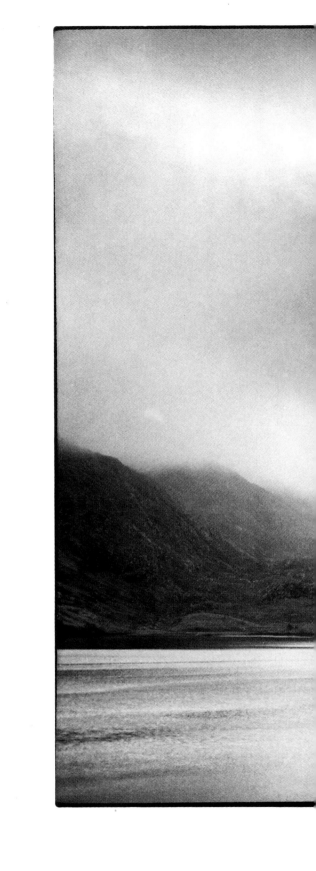

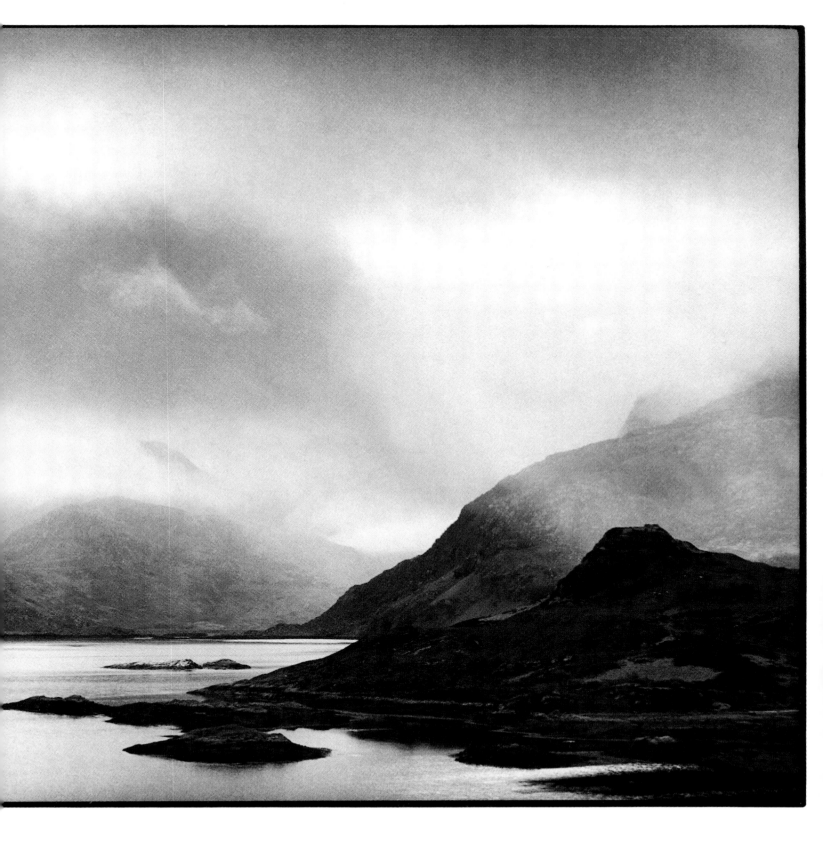

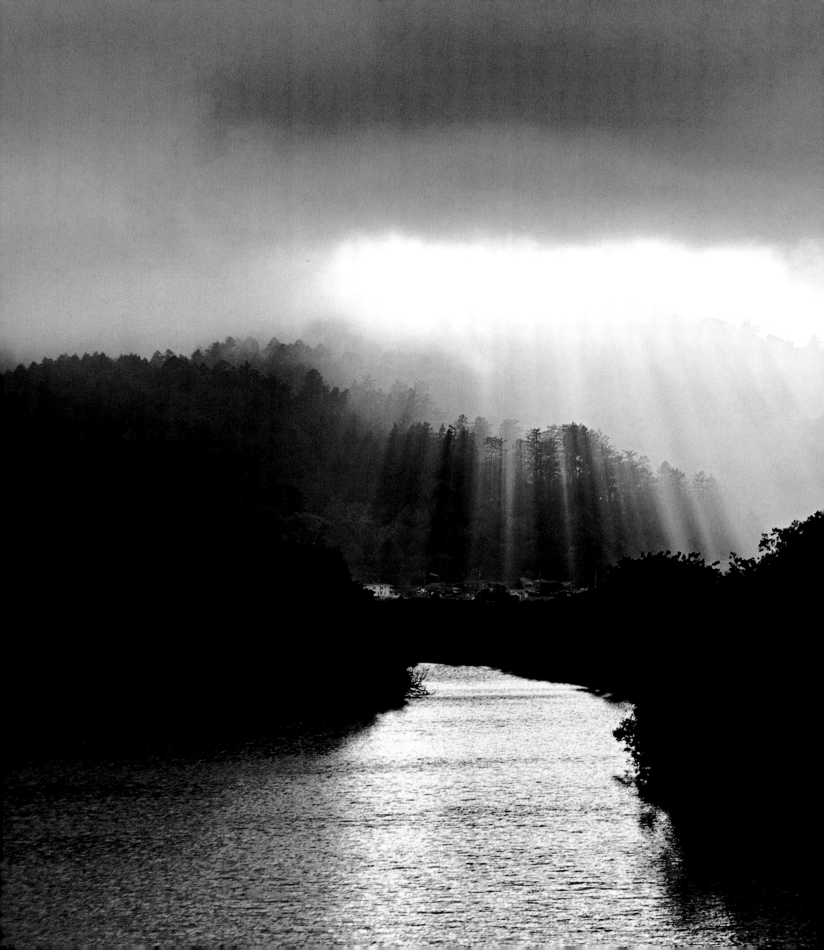

Sunlight Breaks, Papermill Creek by Marty Knapp
Canon F1, 28mm lens, Kodak Technical Pan ISO 25 film.
Exposure 1/15sec at f/22

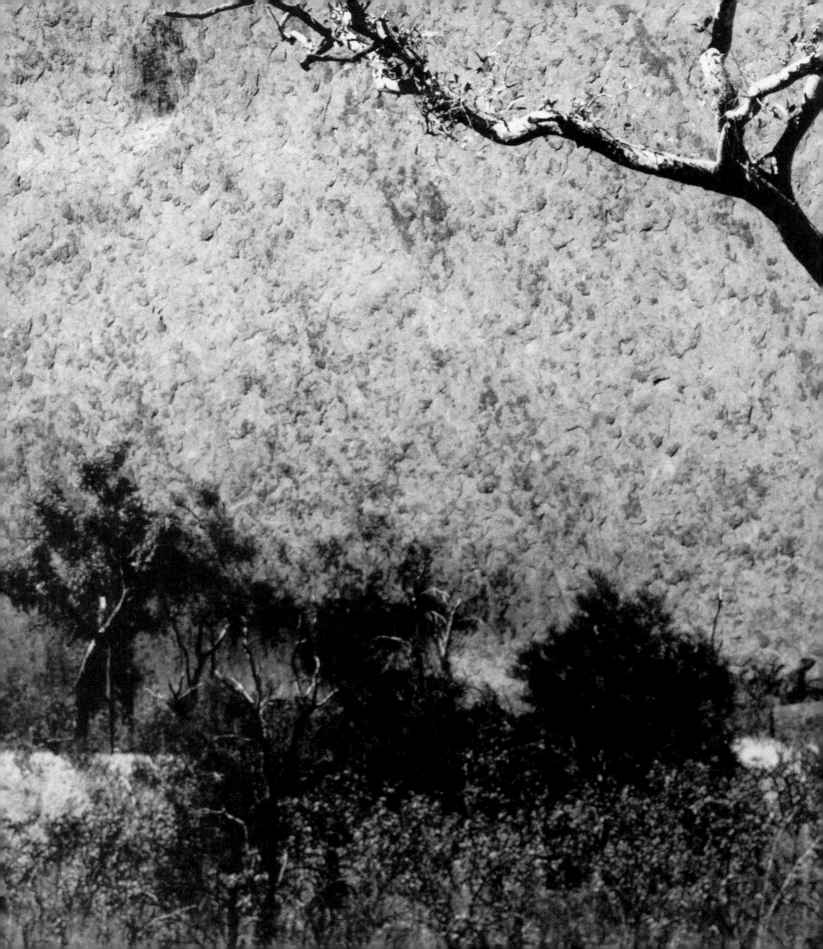

Technique

There are many ways to tackle landscape. In this section photographers explain some of the techniques they've used to produce images that are strikingly different.

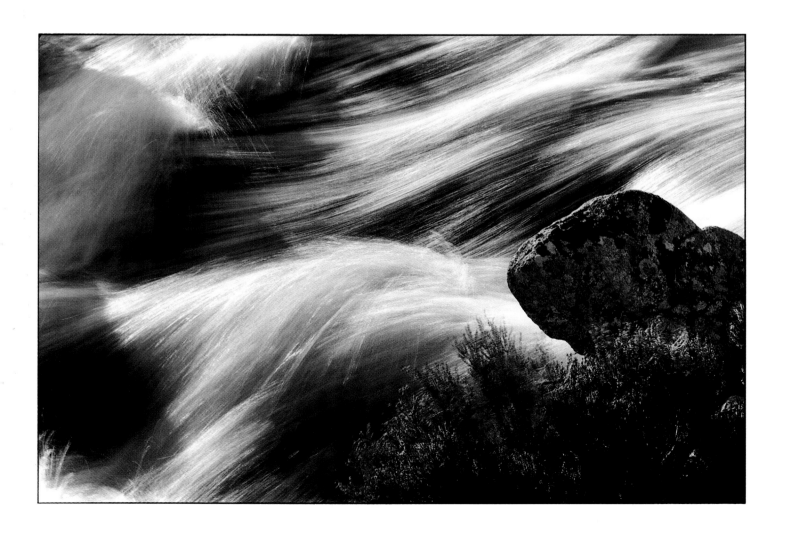

Technique

The Rushing Waters of Eglin Lane by Tom Richardson
Mamiya 645, 150mm, HPX 100 film, 4x neutral density filter and orange filter.
Exposure 1/4sec at f/22

I had in my mind a picture of rushing water that I'd been planning to shoot for ages. I intended to use a slow shutter speed to allow the water to blur, but I didn't want to produce anything too clichéd: I've seen too many shots that have been done like this. I felt there must be a more original way to capture the effect.

What I wanted was to shoot from a side-on position and to find an interesting foreground that would act as a static element to set off the movement of the water. When I came across this scene on the banks of the Eglin Lane while on a walking holiday in Galloway in the southern uplands of Scotland, it was exactly what I was looking for. It had been raining for the entire week, the river was full to overflowing and the water was surging along at high speed.

I set the camera up on an elevated position so that I could fill the viewfinder with the view of the water and cut the background completely out of the composition. Then I fitted a grey 4x neutral density filter, which allowed me to cut down the light reaching the film, and an orange filter was also attached to the lens to cut down the light still more and to lift the contrast.

This picture was taken using a shutter speed of around 1/4 second, but I took a whole series of images at different speeds by way of experiment. Obviously this is one of those subjects that you have to try to visualise. You never really know what you've got until you see the negatives.

Tom Richardson

Printing and Processing The print was toned gently in thiocarbamide. I have developed a method whereby I dilute the initial bleach far more than is recommended in order to keep the intensity of the blacks. This really is one of the most versatile toners you can use and a variety of different colour effects are possible through experimentation. See page 118.

My favourite tip When I'm using shutter speeds this slow, I like to take extra precautions to try to eliminate camera shake. I take an ordinary dog lead with me and attach one end to the barrel of my tripod, just below the tilt and shift head. I put my foot on the other end so that it's held rigid. This acts virtually as a fourth leg, ensuring that the tripod is extremely stable.

'It had been raining for the entire week, the river was full to overflowing and the water was surging along at high speed.'

Technique

Technique

Ayers Rock, Central Australia by John Claridge
Ebony 5x4in camera, 500mm lens, Agfa 100 film.
Exposure 1/60sec at f/64

One of the main characteristics of a telephoto lens is the way that it will pull up distant perspective and apparently compress elements on different planes and bring them closer together. That's a quality that can be used to good effect on occasions in landscape photography, particularly when you're looking for a quirky or unusual angle for a picture.

When I found myself at Ayers Rock, I wanted to come up with something that was slightly different to the conventional view and so I was looking around for ways that I could achieve this. Suddenly I saw what I was looking for, and it had little to do with conventional landscape philosophy. In fact it was a visual joke: I'd noticed that the shadow on the rock in the top right-hand corner resembled a giant kangaroo!

I was lucky that the tree was there, because something was needed in the foreground to add interest and to act as a scale. I knew what I wanted to do and before I even put the lens on the camera, in my mind I could see the scene the way I wanted it.

It's all part of developing an eye for a picture and the more photographs you take, the better this gets. Hopefully by now I've been doing it long enough to see pictures purely by instinct, and this certainly was one of those occasions.

John Claridge

My favourite tip Using a 5x4in camera for landscapes imposes its own discipline. You can't shoot quickly and so everything you do tends to be more considered, and that's a good thing to learn. If you shoot with a 35mm camera then you have another discipline to work with, one where you have more chance of shooting by instinct. Neither way of working is better than the other, they're just different. Though I don't find that mentally the equipment imposes a particular way of working on me, physically it does, and you have to learn to use that to your advantage.

Pointer When you're shooting a landscape, particularly a well-known one, don't get caught up in a conventional approach. Landscape is about more than just picking out a particular view that will try to say everything about a place. Sometimes it can be about picking out details and concentrating on one tiny part of the overall scene. Set yourself a project to visit a famous location and to come away with at least one picture that is completely original to you. It's a useful exercise and will encourage your eye for a picture to develop.

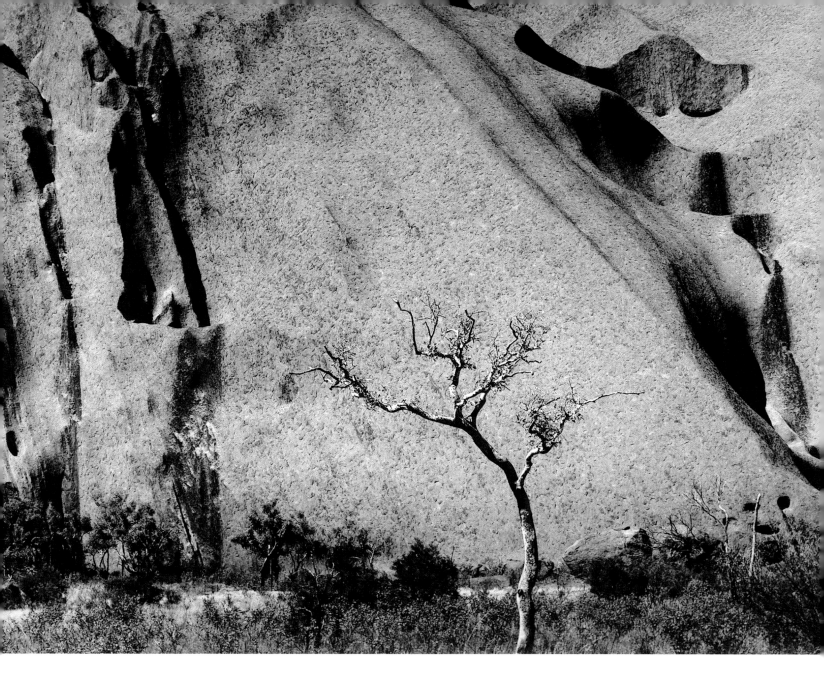

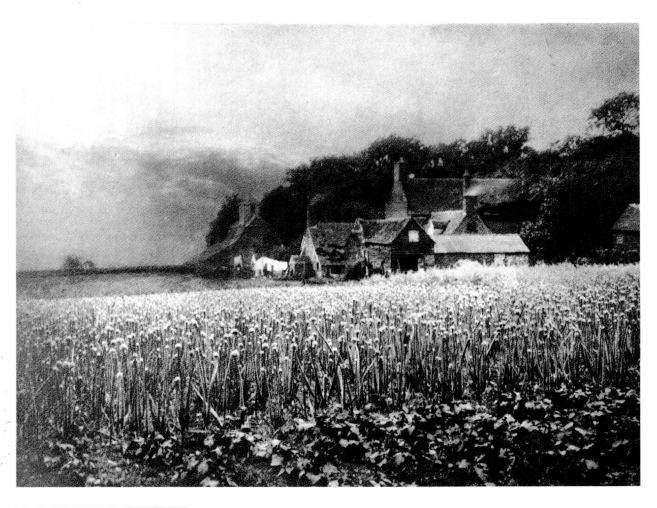

Creation of a pinhole image

subject pinhole image

Technique

The Onion Field by George Davison
Pinhole camera, hole around 1/15in.
Exposure roughly 15mins

The pinhole camera that George Davison used to produce this classic landscape in 1888 is just about the simplest piece of equipment that it's possible for any photographer to use, and yet there is much to be said for the beautifully soft images that can be produced by this method.

The technique relies on the fact that if you produce a clean pinhole of optimum size, it is capable of resolving an image onto film. Although it won't be especially sharp and it will take quite a time to make an exposure, the quality of pictures produced by this process is unique and you'll find that depth of field is infinite. Davison believed there was 'a quality about pinhole diffusion which differentiates it from other means of imparting general softness', and he proved the fact in a series of exceptional pictures that were highly regarded by his contemporaries. The Onion Field even won the Gold Medal of the Photographic Society of Great Britain in 1890, one of the highest accolades of that era.

The optimum size for a pinhole is about 1/25th of the square root of the distance in millimetres from the pinhole to the screen. With a 150mm (5x4in) camera, for example, this gives a pinhole diameter of 0.5mm. Don't get too hung up on the technicalities, however, because you can still arrive at the perfect size for your pinhole through a certain amount of trial and error. If the hole is too small or too large it will lessen the sharpness of the image you produce and you'll be able to change the size of the hole accordingly.

Picture: George Davison/RPS

Pointer Some photographers have produced a good workable pinhole camera by adapting the case of a single-use camera, or you can make up a complete camera by using a light-tight box. If you're using the former, remove the lens and cut a piece of silver foil to fit in its place (or if you're using the latter, simply cut a small square hole in the front of the box that the foil can fit across). Foil makes an ideal material in which to make your hole: carefully twist the pin on its surface until it breaks through and when you're happy with the size of the hole, file away the rough edges from behind. You can even paint the back of the foil a matt black if you want to make absolutely sure that this won't reflect the light inside the camera and cause flare. Film needs to be loaded in a darkroom, and then the camera can be taped together ready for the exposure to be made, remembering of course to put some tape across the pinhole itself, which can then be removed to make the exposure. Modern film materials will need less exposure than film did in Davison's day. Experimentation will show you how long to give but typically, a fast film will need an exposure of around five seconds.

Printing and Processing The Onion Field is printed as a Photogravure. This process, invented in 1879, relies on a photographic etching method. A tissue, coated with gelatine and potassium bichromate, is exposed under a positive, then pressed, emulsion side down, onto a copper printing plate. The tissue and unhardened gelatine, which has received little light, is then washed away leaving hardened gelatine. The plate can then be etched in acid, inked and used as any other printing plate but giving a very detailed impression.

Technique

Prairie Sunrise by Jerry Olson
Nikon F4, 35mm lens, Kodak Technical Pan Film, uprated half a stop to ISO 32.
Exposure 1/125sec at f/16

There's nothing to say that a landscape has to be lit frontally in the conventional fashion, and it can be interesting to turn things around and to look towards the source of the light, the sun itself. This is especially the case if you're dealing with a scene that is already bright and that has the potential to reflect back the light that's falling on it while picking up any shadows that may be thrown. This was the case when I came across this line of sunflowers still defiantly standing in a field now covered by a blanket of snow while driving along a country road near Grand Forks, North Dakota one very cold December morning.

Because conditions were so extreme, I had my Nikon already mounted on a tripod and loaded with Technical Pan film to save on the time that I would spend outside my vehicle. I knew that arriving at a correct exposure would be difficult. Although the wintry sun is not as strong as it is at other times of the year, the meter was still likely to be fooled by the intensity of the direct light and the reflection from the snow's surface. This would lead to overexposure, something that would ruin the effect of the snow by putting too much tone into the foreground. My first reading, taking into account the fact that I'd uprated my film half a stop to ISO 32, was 1/30sec at f16. I knew that this would result in an overexposed picture, so I bracketed from this point, shooting at 1/60sec and then 1/125sec. The final exposure gave me a negative that I knew could be printed the way I wanted.

Jerry Olson

Printing and Processing The print was made on Ilford Multigrade IV deluxe fibre-based paper, which was processed in Zone 6 paper developer. The negative chosen to work from didn't feature equal densities in the sky and the foreground areas. Because of this it was necessary to give an exposure for the paper that was calculated to produce the correct tone in the foreground and then to dodge this area, i.e. to cover it with moving hands to prevent further exposure, while three times this exposure was given for the much denser sky.

Composition The rule books suggest that the horizon in a landscape should be around two-thirds the way up a picture, but the effectiveness of the composition here relies on the fact that sky and foreground occupy almost exactly half the area of the picture each. The thin strip of darker land at the top of the field marks the divide between the two areas and underscores the fact that the picture is dramatically cut in two, further intensifying the strikingly geometric feel of this image.

'Although the wintry sun is not as strong as it is at other times of the year, the meter is still likely to be fooled by the intensity of the direct light.'

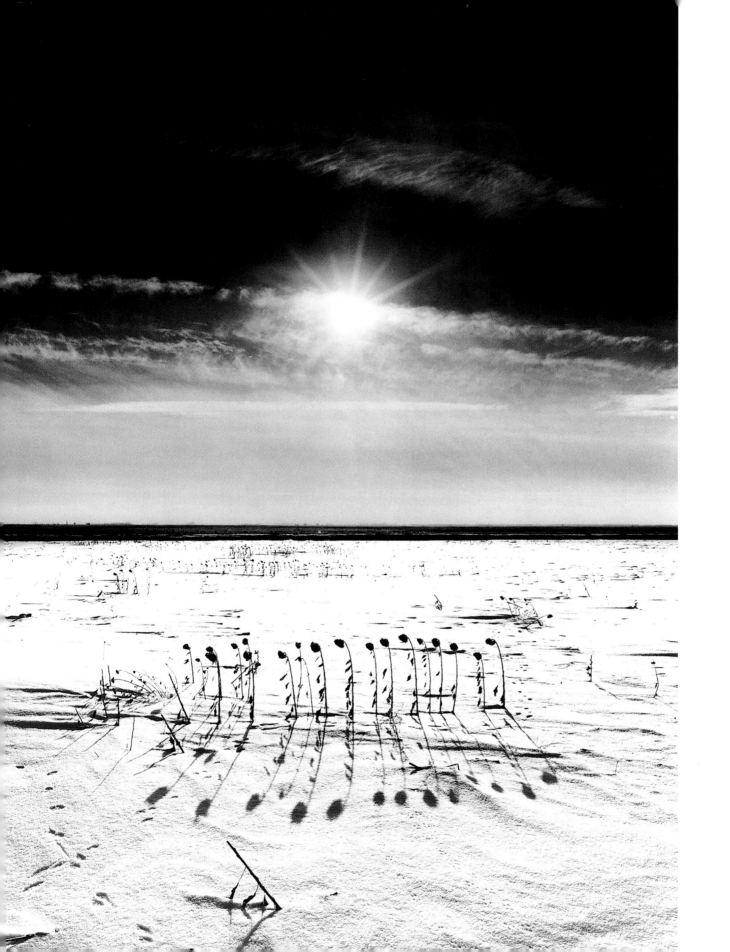

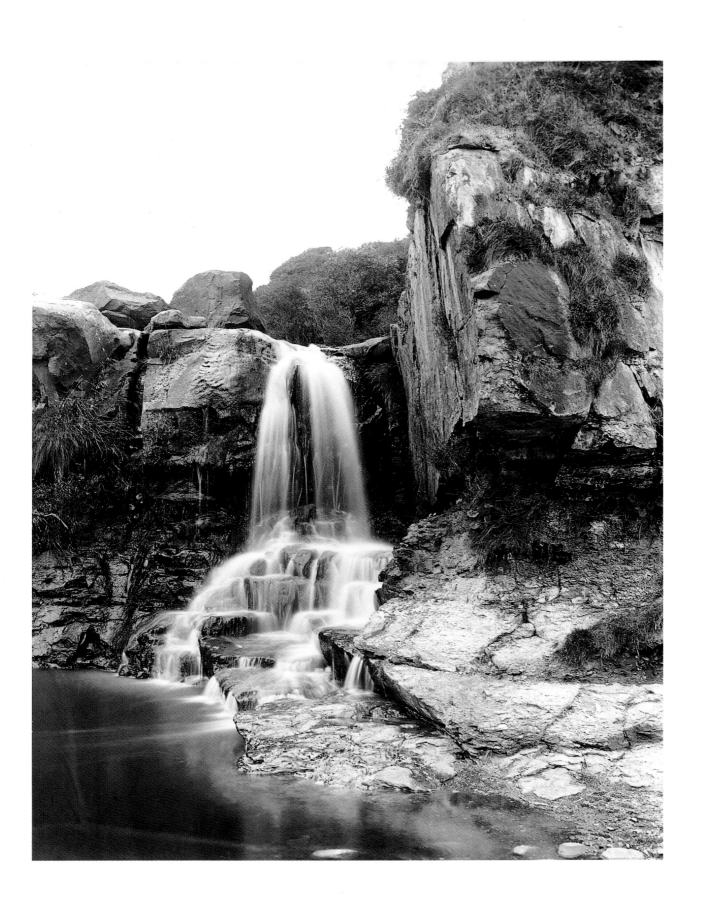

Waterfall on Thorny Beck by Frank Meadow Sutcliffe
Whole Plate camera.
Film and exposure unknown

If anything, such as water or the leaves on a tree, is moving in a landscape, then a slow shutter speed will allow it to blur, which has the potential to add greatly to the pictorial effect of the scene. Victorian photographers such as Frank Meadow Sutcliffe, who was widely regarded as one of the greatest of all the early exponents of landscape, were using film so slow that it left them with no choice but to use long exposures. Consequently they became experts in how to turn this fact to their advantage.

Waterfalls were a favourite subject and the exposure Sutcliffe was using here, which was several seconds long, has allowed the cascading torrent to take on the appearance of a length of silk. The misty quality is due to the speed with which the water is flowing and is even apparent on the surface of the lake. Oddly, however, this is closer to the effect that the eye sees than the result that might be achieved using a fast shutter speed that clinically freezes it. Water, after all, is a fluid part of the landscape, and pictorially is often all the better for being shown as such.

The combination of a slow emulsion, perhaps Kodak's ISO 25 Technical Pan material, the minimum f-stop and a dull day might be enough to give an exposure of a second or so. If, however, you want to achieve a guaranteed exposure time of two to three seconds to allow the water to appear as dramatic as it does here, then you'll need to use a neutral density filter over the camera's lens. This effectively cuts the light reaching the film down by a stated amount and absorbs all wavelengths almost equally, and therefore has no influence on the tones each colour will record on black-and-white film.

Composition The position Sutcliffe chose for his camera placed the waterfall centrally in the composition where it would achieve maximum impact, while it also allowed him to use the mass of rock on the right-hand side to achieve vital balance. This takes up around a third of the picture, the waterfall another third and the area to the left the final third, proportions that follow faithfully the rules of landscape composition. However ancient these principles may be, they still can teach much to landscape photographers working today. Mask the picture with your hand to cut off the left-hand side of the picture: with the waterfall and the rock mass now taking up equal proportions of the picture, much of the impact of the picture has now been lost, the rock mass now dominating the picture.

Pointer When using shutter speeds that may be several seconds in length, use a cable release to activate the camera, because this will eliminate a major cause of image blur. With a subject such as landscape it's also possible, if your camera is an SLR that features a mirror lock, to arrange the composition and then flip the mirror up before taking the picture, further lessening the chance of shaking the camera.

Technique

I wanted to come up with a new angle for my picture of the Upper Yosemite Falls which, considering the number of visitors who visit this great National Park, isn't an easy thing to do. By walking half a mile from a parking area into the Yosemite Valley on a well-maintained trail, however, I was able to come up with this view from the meadow below the falls, which is very different to the conventional picture postcard scene. I was a considerable distance from the falls, but by using a long lens I was able to bring it up to a reasonable size in my viewfinder. Best of all, by positioning myself carefully I could create some important foreground interest by arranging these isolated trees so that they were framed against the water. The typical perspective offered by a long lens, which reduces the effect of depth, made the trees appear closer to the base of the falls than they actually were and heightened the relationship between these two elements of the picture, which was the effect that I wanted. The lens I was using couldn't bring the falls as close as I wanted, and so I printed up just the centre of the negative, effectively achieving a viewpoint that was the equivalent of one that a much longer lens would have delivered.

I've seen the falls photographed many times, but I've never seen anyone else achieve this particular view. I'd like to think that my picture was unique, but I'm sure it isn't!

Jerry Olson

Upper Yosemite Falls by Jerry Olson
Toyo 5x4in camera, 400mm f/6.3 Schneider lens, Kodak T-Max ISO 100 film. Exposure 1/30sec at f/22

Printing I printed this negative onto Ilford Multigrade Deluxe IV fibre-based paper, but found that I was losing a little shadow detail because the rock on both sides of the falls was recording slightly too dark. I solved the problem by dodging at the printing stage: this is to say that I used my moving hands specifically to hold back some of the exposure these areas were receiving and this served to even up the density throughout the print.

Pointer The camera was mounted on a tripod for this exposure, but a strong wind and a heavy camera made it difficult to prevent camera shake. To make a tripod steadier, a good tip is to weigh it down. If you're operating close to a vehicle, you could take a heavy sandbag with you that could be suspended from the central column of the tripod to make it more solid. If you have to improvise, another option would be to tie a piece of string around any suitable rock that came to hand and hang this from the tripod's central column instead.

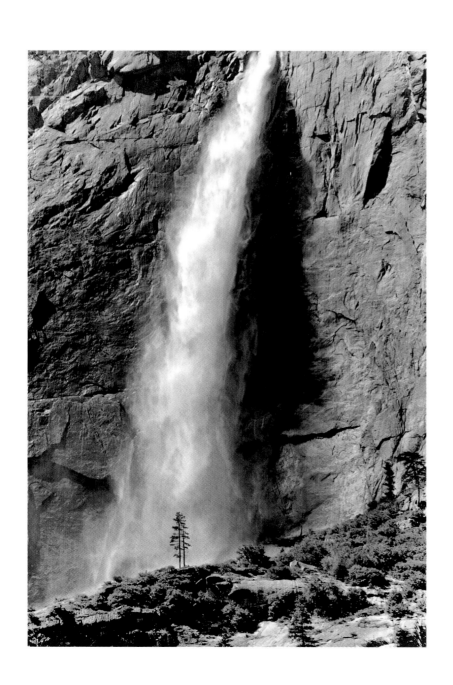

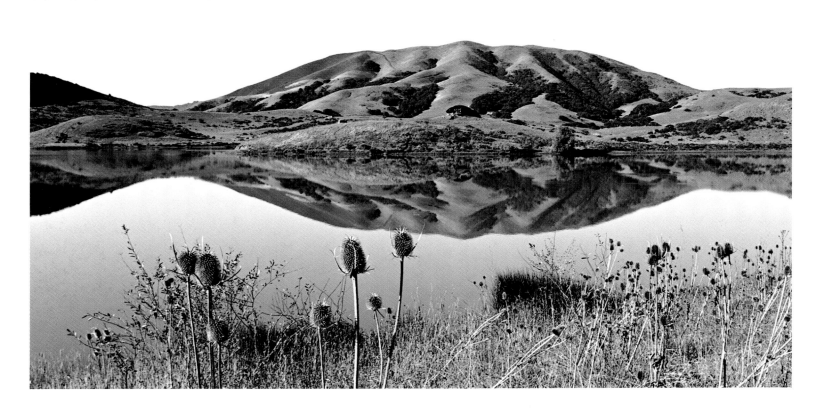

Technique

Black Mountain, Nicasio by Marty Knapp
Canon F1, 28mm FD lens, Kodak Technical Pan film.
Exposure 1/8sec at f/22

There are certain moments when landscape photography can be totally spectacular, when something like a cloud formation or an atmospheric effect can fleetingly create a scene for the camera that is really special. When I took this picture at Black Mountain in California this was one of those occasions, because seen in the usual way this view would be nothing out of the ordinary. I had been to this location before, however, and knew that there was the potential here for an amazing reflection, but I'd never managed to achieve a satisfactory picture because conditions had never been perfect. I knew the best time to visit would be at sunrise in the autumn, so I made a special effort to get there at that time. The stillness that lasted just an hour or so was unbelievable and that's what's allowed the reflection to be so perfect.

Pointer I took this picture using a 35mm camera and for a long time insisted on printing the entire frame, which includes around twenty per cent more sky and foreground detail, both of which detract from the strength of the image. I hadn't at that point understood the importance of cropping and how it might serve to strengthen a picture, but when eventually I did, I found that the picture was improved immensely. Now, if I think it's necessary, I have no qualms about cropping elements from a picture if I think that by doing so, I'll end up with a stronger image.

Many people see the picture and imagine that it was created by a multiple printing technique, but this wonderful shape created by a perfect mirror-like reflection is genuinely what I saw. It's one reason that the foreground is so important: not only does it add essential depth to the picture, but it establishes in the eye of the viewer what exactly is happening and what is the reflection and what is reality. A great depth of field was required to allow me to keep this foreground acceptably sharp, and I achieved this by adopting the principles suggested by Ansel Adams, setting the aperture to its minimum and focusing to the hyperfocal distance.

Marty Knapp

Technique The hyperfocal distance is the distance from the lens to the nearest object that is just acceptably sharp when the camera is focused on infinity. If you focus initially on infinity and then refocus to this hyperfocal point, i.e. to the distance from where depth of field will extend just to infinity and no further, you'll achieve the maximum depth of field possible with a given aperture. Since the hyperfocal distance will change according to the aperture that's set, however, moving closer to the camera as the f-number becomes higher, you will need to view the scene through the aperture that's going to be set, so the lens you use will need to feature a stop-down facility.

'Many people see this picture and imagine that it was created by multiple printing, but this wonderful shape, created by a mirror-like reflection, is what I saw.'

Printing a

Printing and Processing

Welsh Mountains by Dr Tim Rudman
Canon EOS 600, 24mm, XP1 film.
Shutter speed set by aperture priority setting at f/22

Sometimes the contrast within a scene is such that it's impossible to come up with an exposure that will produce a negative which will print satisfactorily on a single grade of printing paper or, if it does, it may not match one's pre-visualised image. The latter was the case here: I spotted this wonderfully rugged landscape in north Wales en route to conducting a printing workshop, and this picture was actually set up and taken from a lay-by. I chose to feature a boulder in the foreground that had been placed there to prevent cars venturing too close to the edge of a sheer drop, but the contrast in tones between that and the distant mountains was immense. I also wanted to play down the stone wall that cut across the middle of the picture.

The technique I used was made possible by the use of variable contrast paper, printing paper that can produce different levels of contrast depending on the filtration it receives. I used Ilford's Multigrade FB and developed in Ilford FF high-contrast developer (now discontinued). The two prints here show the mundane appearance at high- and low-contrast settings. A straight print on the grade 5 setting produced a good level of contrast for the foreground, but allowed the sky and some of the mountain to disappear. At grade 1 ½ the background was at an acceptable level of contrast, but the foreground was too dark. The answer was to print the top half at grade 1 ½ and the bottom half at grade 5.

The centre of the picture was set for a contrast level of grade 0 and burned in to darken down and effectively to remove the wall. Further burning in was carried out to enhance the sun in the sky and to darken down the area around the rock.

Dr Tim Rudman

 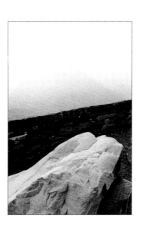

Composition The use of a wide-angle lens at its minimum aperture has allowed a great depth of field to be achieved, and this has increased the relationship between foreground and background. The wide-angle is one of the most popular lenses for the landscape photographer to use, because it can be used to emphasise the importance of foreground detail through the characteristic perspective that it offers. An arresting foreground can then be used to set off distant detail and to lead the eye naturally into the picture.

Printing and Processing

Dartmoor Trees Against the Moon by Dr Tim Rudman
Yashica TL Electro X, 70–210mm zoom, Sky FP4, foreground Tri-X.
Exposure unknown

I saw these wind-sculpted trees on Dartmoor one rainy afternoon and knew that as a subject for a straight picture, they didn't really have enough going for them in terms of content, interesting though their shapes undoubtedly were. The picture was taken anyway, and subsequently I started to look for a more interesting sky that might add the necessary mood to lift the picture.

Later I took a picture of the moon in a cloudy sky that I thought with a little work, might prove ideal. The negative needed to be turned upside down and back to front to get everything into the correct position, but it worked.

This effect requires sequential printing of two negatives rather than photography as a sandwich. This method allows alterations in contrast, density and magnification for each negative, as well as individual dodging and burning for each component.

Pointer It's a good idea to shoot pictures of suitable skies as and when the opportunity arises. Those that are ideal are usually uncluttered by any details, while featuring interesting cloud formations and possibly, as here, an outline of the moon. To achieve a result that looks believable, care has to be taken to match negatives in ratio to each other. Where relevant, you must also ensure that the direction of light in the picture is consistent with the introduced light source.

Blending low-key subjects such as this is not difficult, since only rough dodging at the overlap is required. The dramatic effect can be heightened still further by printing the negative darker than would normally be the case. Suddenly the wet and rather bland afternoon on Dartmoor becomes a wild and stormy night, with the trees silhouetted against the moon and clouds.

Dr Tim Rudman

'Blending low-key subjects such as this is not difficult, since only rough dodging at the overlap is required.'

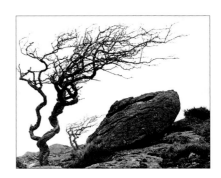

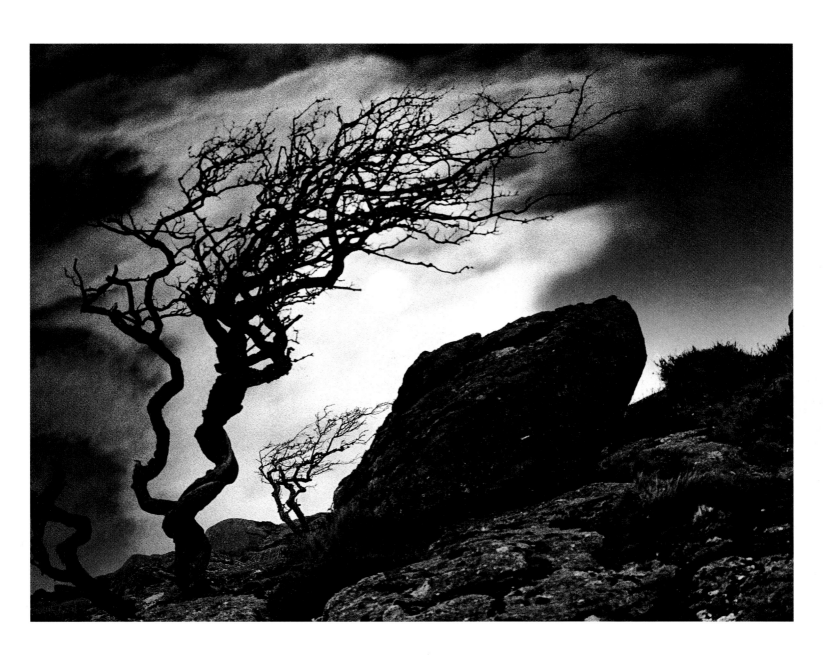

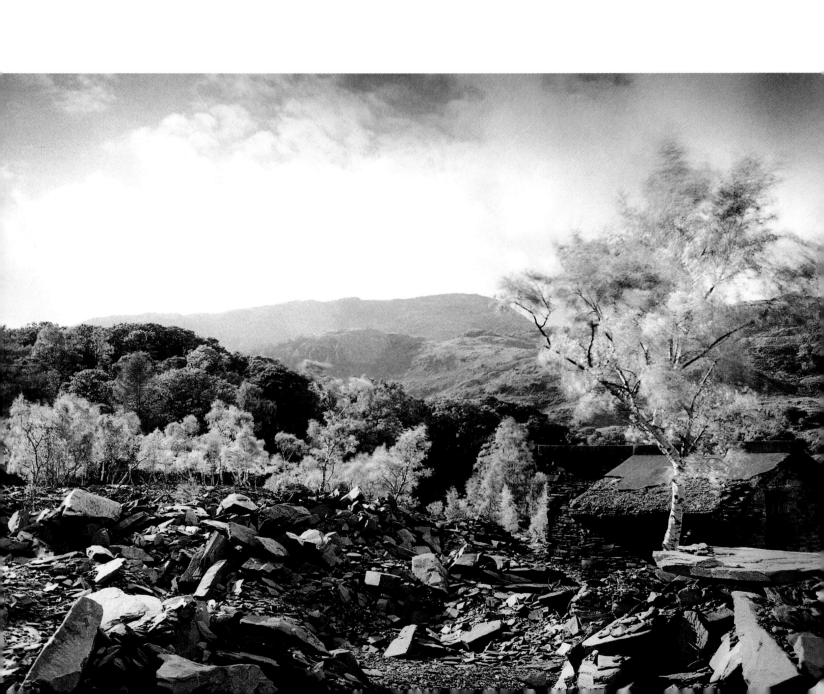

Printing and Processing

Hodge Close Quarry, Cumbria by Tom Richardson
Mamiya 645, 45mm lens, Agfa APX 100 film.
Exposure 1/4sec at f/22

Toning is one of the best ways of finishing a black-and-white print. It will add a degree of colour to the picture and make the image more archivally permanent and there's an amazing amount of flexibility built into the way the finished print will appear.

This picture of Hodge Close Quarry near Coniston in Cumbria, for example, was given a dual tone effect using thiocarbamide and blue toners. The result is a subtle mix of colours that enhances the final result without taking it dramatically away from its black-and-white origins. Dual toning involves the use of a combination of toners and I adapt the technique a little by using the chemicals at greater dilutions to slow the process down a little and to make it more manageable. The first stage in the toning of this picture saw the original black-and-white print put into a bleach solution that had been diluted twenty to one rather than the recommended ten to one. At this strength the print will take perhaps eight minutes to be bleached right back, but I remove it and wash it quickly at just three minutes or so, enabling the blacks to retain their density while the highlights start to fade.

Then the print is placed in thiocarbamide toner, again diluted to around half its recommended strength to slow down the process. The highlights take on the light brown colour of the tone, but the shadows stay black. Once the print has taken on the colour I want, I then place it in full-strength blue toner – diluting doesn't seem to affect toning times with this solution – and allow the blacks to take on a cold blue tone, while the highlights stay brown.

The best thing about this process is that it's almost impossible to repeat a print exactly, such are the variations that are possible. This means that every print is unique and you'll obtain a whole range of slightly different effects each time you use this technique.

Tom Richardson

Technique I wanted to introduce movement into this picture, but there was too much light around to allow me to use a really slow exposure, even when I stopped my lens down to its minimum aperture of f/22. The only way I could select the 1/4sec exposure that I wanted was to fit a neutral density filter to the lens. This is a colourless grey filter that acts to reduce image brightness but which has no other effect, even when shooting colour. They come in varying strengths and allow the photographer greater control over lighting situations that he or she may encounter. There are even graduated neutral density filters available that will help to even out the contrast levels in a picture if the sky happens to be much brighter than the rest of the scene.

My favourite tip The thiocarbamide/blue tone combination that I used gave the print a subtle finish, but there are many other combinations that work equally well. Try copper and blue, blue and selenium or thiocarbamide and gold toner combinations, using the technique described here. You can see the kind of finish that you'll obtain without risking an entire print by using test strips.

Printing and Processing

Trees at the Sandpits by Dr Tim Rudman
Canon EOS 600, 24mm lens, Kodak High-Speed infrared film
rated at ISO 200, red filter.
Exposure unknown

In order to make this landscape – taken at the Sandpits near Horsell Common in Woking – look slightly mystical, I applied a little diffusion at the printing stage. Diffusing under the enlarger gives a different appearance and therefore a different mood to that which you might achieve by using a diffuser over the camera's lens at the taking stage. Conventional in-camera diffusion causes the highlights to bleed into the shadows. A diffuser under the enlarger lens at the printing stage has the opposite effect with the shadows bleeding into the mid-tones and highlights, creating a dark halo effect.

I used a Cokin No1 diffuser under the enlarging lens to make this print and applied this for just one third of the exposure time for subtle effect. A Cokin No2 diffuser can be used for marked diffusion, or both filters can be combined. I use a variety of other materials – such as crinkled Cellophane sweet wrappers, stretched fabric or stocking and Anti Newton glass – for other diffusion effects, as each has its own characteristics.

Finally the print was split-toned. I used a bleach bath diluted to ten per cent of its recommended strength and bleached back only the highlights. I toned with thiocarbamide. The toner only works on the parts of the print that have been bleached, and therefore the mid-tones and areas of shadow were largely unaffected here, while the highlights took on a subtle shade of brown.

Dr Tim Rudman

Mood The use of infrared film can be remarkably effective when applied to landscape photography. It gives a scene a slightly ethereal other-worldly effect and features a natural propensity to allow the highlights to bleed into the shadows creating a halo effect – that's the same as would be achieved by in-camera diffusion and the opposite to the effect created by diffusing at the printing stage. The combination of the infrared effect and diffusing under the enlarger has greatly enhanced the mood of the picture. Some photographers have used in-camera diffusion in combination with infrared film to great effect when photographing spooky subjects such as graveyards and haunted buildings.

Pointer The use of a wide-angle lens has helped to emphasise the shape of these twisted roots and their relative size to the trees behind. The landscape photographer can have a great influence over the way a scene is depicted simply through choice of lens. A longer lens would have appeared to have brought trees and roots closer together and created a quite different – and ultimately not so dramatic – effect.

'Diffusing under the enlarger gives a different appearance and therefore a different mood to that which you might achieve by using a diffuser over the camera's lens.'

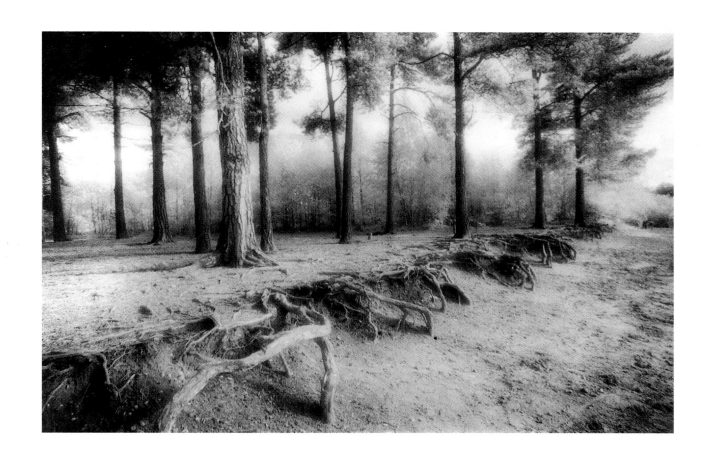

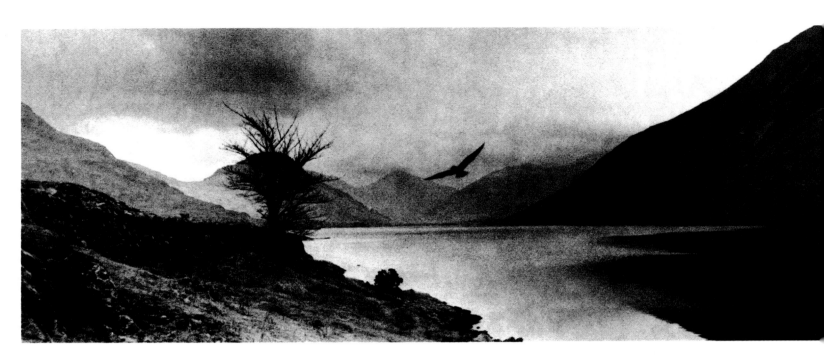

Printing and Processing

Hawk at Wastwater by Carl Lyttle
Canon EOS 1, 24mm lens, Agfa 100 film.
Exposure unknown

I took this landscape while on a family holiday in the Lake District and despite some people thinking that it looks like a computer manipulation, it's a perfectly straight picture. We were sitting and having a picnic and the hawk just flew into the scene; it's one of those classic situations where you don't know quite what you've got until you see the contact print, but in fact I managed to capture the hawk in exactly the right position.

I wanted to print the picture in a way that would give it an illustrative feel, and so it was important to take away some of the detail and to add some texture to the scene. I did this by choosing a printing paper, Kentmere Document Art, that had the finish of a watercolour paper and then I completed the effect by simply turning the paper over and printing through the back of it. This wasn't a major problem, because the paper is quite thin and the image printed through quite quickly. The effect was to soften everything down and to add the texture of the paper itself to the picture. The final stage was to tone the picture in thiocarbamide to take the picture yet another stage further on from a straight black-and-white picture.

Carl Lyttle

Pointer Although this picture was taken with a 35mm camera, I felt that it featured too much foreground and sky. Neither really added anything because all the interest was concentrated into the middle of the picture, so I cropped into this to achieve a result that has the same dimensions as a panoramic format.

Technique Thiocarbamide toning is a two-bath process that consists of a bleach and a toner stage.
Formula
Toner bleach; potassium ferricyanide 100g; potassium bromide 100g; add water to make one litre of stock solution.
Thiocarbamide toner – Solution A
Water (40 deg c) 750ml; thiocarbamide 100g; add water to make one litre.
Thiocarbamide toner – Solution B
Water 750ml; sodium hydroxide 100g; add water to sodium hydroxide – not the other way round – to make one litre.

Process Bleaching – For fully toned prints, dilute one part of bleach to at least nine parts of water, then immerse the print and agitate evenly until it turns a pale straw colour. For partially-toned or split-toned prints, increase the dilution and remove the print before all the silver has been bleached. Wash thoroughly to remove all yellow bleach stains.
Toning – Solutions A & B can be mixed in the following ratios to give varying shades of brown.

Sol A	Sol B	Water	Colour
10ml	50ml	460ml	Dark brown
20ml	40ml	460ml	Cold brown
30ml	30ml	460ml	Mid brown
40ml	20ml	460ml	Warm sepia brown
50ml	10ml	460ml	Yellow brown

Immerse bleached print into toner, agitate until print returns to its original density, remove and wash thoroughly. Take care not to breathe in the chemicals during the bleaching and toning processes. Work in a well ventilated room, wear a mask and always handle prints with tongs or wear rubber gloves to prevent the skin coming into contact with the chemicals.

Printing and Processing

The Lone Tree by Dr Tim Rudman
Canon EOS 600, 200mm setting of a 70–210mm zoom,
Kodak High-Speed infrared film rated at ISO 200.
Exposure unknown

The combination of lith printing and selenium toning can give a very distinctive and almost painterly effect, especially if the subject is chosen with care.

I took this picture of a flock of sheep moving across a field while I was on a canal boating holiday one autumn, using infrared film and shooting through a red filter. I knew the effect I wanted to achieve – one where detail was kept to an absolute minimum to give an impressionistic effect – so I overexposed the negative for tonal compression and then overdeveloped it.

This print was made on Fotospeed's Tapestry Paper. This is a heavyweight paper with a textured finish that, combined with the printing treatment here, lends the print the appearance of a watercolour. The paper was overexposed by three stops and developed in highly diluted lith developer until the required effect was reached, at which point the print was 'snatched' from the developer, transferred swiftly to the stop bath and then fixed.

At this stage the print had an overall pink tint, but I wanted to add another tone to the sheep and to the tree to allow them to stand out more from the field. To achieve this I immersed the print in selenium toner that had been diluted one to five. In this toner a lith print on this paper will change slowly from pink to purple/blue and then to grey and brown, the darker tones being affected first, the lighter tones following. This can give a multicoloured effect. In this case I wanted a more muted result, but with some colour contrast between the tree and the sheep and the rest of the picture. Once my print reached the point I wanted, it was treated with hypo clearing agent and washed to archival standards.

Dr Tim Rudman

Composition Landscape doesn't need to be full of detail. Here it's the very lack of that element that has proved so effective, aided by the fact that the picture was shot with that end in mind. A horizon devoid of all but a solitary tree has formed the backdrop to a closely grouped flock of sheep. Even a few stragglers dotted around the field would have distracted the eye and spoiled the simplicity of the composition, as would the intrusion of further trees or bushes on the horizon. Scenes that are stripped down to their basics like this can almost become abstract in their simplicity.

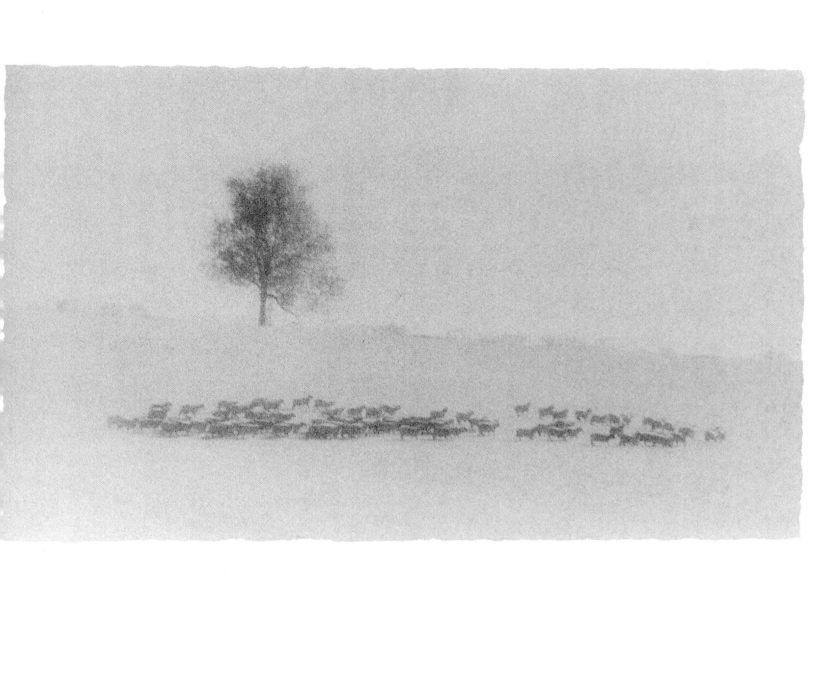

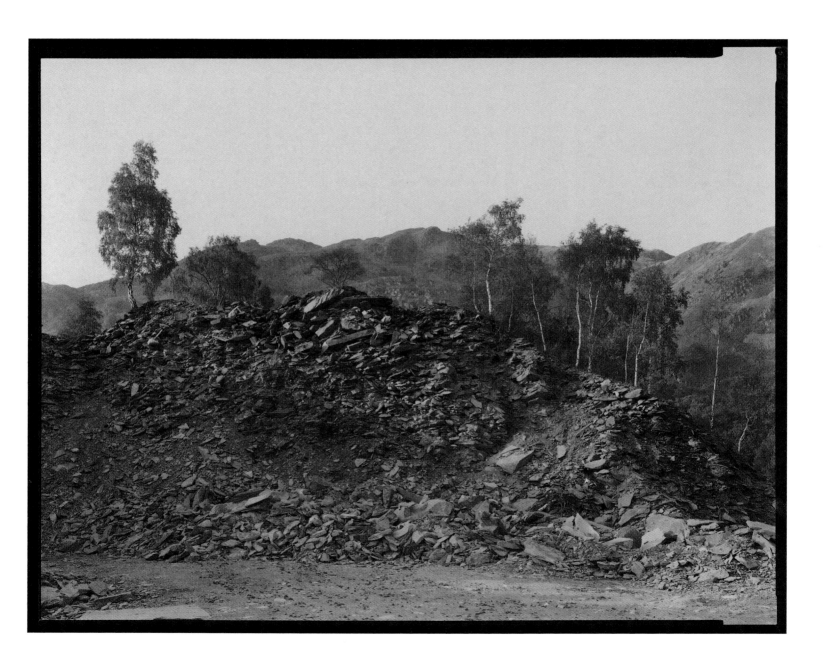

Printing and Processing

Disused Lake District Slate Quarry by Martin Reed
John Nesbitt 10x8in field camera, Agfapan APX 100 film,
300mm Symmar lens (slightly wide).
Exposure 1/30sec at f/11

I took this picture at a disused slate quarry in the Langdale Valley region of the Lake District, as part of a series that I was working on that showed the heavy-handed trace of man on the natural environment. I also wanted to obtain a large negative that I could use as the basis for some experimentation with vintage printing techniques, most of which rely on contact printing. I was particularly interested to see how well detail was retained using one of the more delicate processes and, to this end, I produced this salt print which I think has done great justice to the scene. This is one of the earliest of all the photographic printing processes, having much in common with the methods used by Fox Talbot in the middle of the 19th century, and it has the added advantage of being one of the easier ones to master.

Martin Reed

Technique Mix up a two per cent solution of salt water by adding 20gms of sodium chloride (sea salt from the supermarket) to one litre of cold tap water. Pour this mixture into a clean developing dish and immerse the paper of your choice in it, letting it soak for around five minutes, then hang the paper up to dry overnight. Alternatively you could speed things up by letting the paper drain and then finish the drying process with a hair-dryer or a small fan heater. At this stage the paper is not light-sensitive, so the operation can be carried out in daylight.

Next you need to mix two separate solutions. One is a mixture of 50ml of distilled water and 12gms of silver nitrate and the other is 50ml of distilled water and 6gms of citric acid. When both are completely dissolved mix them together and put the liquid into a small brown screw-topped bottle ready for use. The citric acid acts as a preservative and stops the silver coating from darkening before you can use it. Now you need to coat the salted paper with the silver. This needs to be done in subdued daylight or normal tungsten room lighting. Avoid working in a room with fluorescent light. Then apply the silver/citric acid to the paper with either a flat brush or a glass rod, and then dry the paper with a hair-dryer or a fan heater. The glass rod method used for the print here, which involves squirting a line of the chemical under the rod using a syringe and then squeezing this across the paper through several sweeps, gives remarkably even coverage.

At this stage the coating is virtually invisible, so mark the back of the paper with an X so that you know which side is the front. Now take your negative, which will work best if it's contrasty and place it dull (emulsion) side down on the coated side of the paper. Place this sandwich in a printing frame and then place this, glass side up, in daylight or sunlight or under an ultraviolet lamp. Within a few minutes the silver coating outside the edges of the negative will darken. At regular intervals of three or four minutes (more like once every minute if using the sun as the exposure source), unclip one part of the hinged back of the printing frame and check the progress of the printing, taking care not to move the negative and print out of register.

When the print is exposed to the point that all the tones are correct and the highlights have sufficient detail, take the frame out of the light and remove the print. If everything has gone to plan, you should have an image that is a rich reddish-brown and if you've used the brush method of application, you'll also have an irregular dark border caused by the silver being brushed outside the confines of the negative.

The print now needs to be processed. In subdued daylight or tungsten room lighting place the exposed print face up in a clean developing dish and wash it in running water. The unused silver nitrate will turn the water slightly milky and when this disappears – usually after about four to five minutes – the washing is finished. Then make up a fixing bath consisting of 500ml of cold tap water, 25gms of sodium thiosulphate powder, 2gms of sodium carbonate, and immerse the print face down in this for about five minutes. The colour of the print will change in the fixer to a somewhat unattractive ginger brown colour, but it will revert to its original colour when it is washed and dried. When fixing is complete, wash the print for thirty minutes in running water, remove excess moisture with a sheet of blotting paper and then hang the print up to dry naturally. The finished result should be stable enough to use and display in the conventional manner.

Finishing,

xhibiting and Websites

You've taken and printed your picture and now it's time to show it the world. Thanks to the Internet the display possibilities that exist are wider than ever before. This section gives advice on how to make sure that you're doing your pictures justice when you present them.

Namib Desert II by Simon Norfolk
Mamiya 6, 75mm lens, Tri-X film.
Exposure 1sec at f/22

It's amazing how often photographers put maximum effort into the production and printing of a picture, only to neglect the final framing and mounting stage. And yet the presentation of a picture is a vital part of the whole process, and it's entirely possible that a picture could lose much of the impact that the photographer has worked so hard to achieve simply through lack of care in its finishing.

If you want your picture to last and to be shown off to best effect, there are certain key steps to follow. At the printing stage it's very important to ensure that fixing and then washing is extremely thorough. Toning can also add to the permanence of an image: a light selenium tone is used by many printers because this has little effect on the normal black-and-white tones, but helps to make them more stable. Tones such as thiocarbamide and sepia will also add to a print's archival qualities, and the colour they add to a picture is often beneficial as well.

Once a print has been washed and dried, it should be carefully spotted with archival inks to make sure that there are no dust marks or hairs visible. The picture is now ready for mounting.

Mounting The job of the mount is to set the picture off and to create an area around it that is plain and unlikely to distract. The width of this mount is down to personal choice, though some pictures that are printed as miniatures often benefit from a wider surround in ratio than prints that are larger. Keep the colour of the mount neutral – with black-and-white images white or light cream is the usual choice – because it will then be able to carry out its job efficiently and well, and the picture itself will remain the centre of attention. Great care needs to be taken over the cutting of the mount: generally specialist tools are required to ensure that a smooth bevelled edge is created. If you try to cut a mount using just a scalpel and a steel edge, the chances are it will look messy and you will slice through at least one or two fingers. Visit an art shop and ask for advice from the staff there – they will recommend the equipment that you need.

The Print Room at the Photographers' Gallery in London handles thousands of valuable photographic prints every year, and often arranges the framing and mounting of pictures for purchasers. Print Manager Fiona Duncan explains the policy on mounts: 'Generally when we sell a print,' she says, 'we mount it in archival acid-free board. One board is used as the backing board and on this we create three small pockets from archival tape which hold the print gently in place. The print doesn't need to be fastened any more securely than this, and this method allows it to be removed easily at a later date if required. Then a window mount needs to be cut so that it frames the picture, and this is connected to the backing board along one long edge using archival tape. This means that it's effectively hinged and can be brought across the picture. Now the picture is ready for framing.'

Framing Once again, frames are a matter of personal choice, but often it's those that are the simplest in terms of design and colour that work the best. A black frame, for example, can look stunning when it's surrounding a classic black-and-white picture, whereas one that features a strong colour or an intricate design will start to fight the picture. 'The only other colour apart from black that might work on occasion, particularly with vintage black-and-white prints, is gilded silver leaf,' says John Dawson, a Director of John Jones Frames, who carry out much of the framing for the Photographers' Gallery Print Room.

'We would normally suggest that frames shouldn't be more than 1/2in wide for pictures up to around 20x16ins, while above that size the width can rise to 3/4in without becoming too dominant. The mount should ideally be around 3ins in width increasing to 31/2ins at the bottom for prints up to 20x16ins, and again this can rise a little, to 4ins perhaps, for larger prints.'

The final stage of the framing process is the selection of glass and for archival purposes, you should select a material that offers UV protection, because this will give your print a longer life, particularly if it's going to be hung in a room that attracts a lot of daylight.
John Jones Framing Department can be contacted on 020-7281 5439

Exhibiting

Trees in eastern Turkey by Simon Norfolk
Mamiya 6x6cm, 75mm lens, Tri-X 220 film.
Exposure 1/60sec at f/8

I had the idea for a project to photograph landscapes in some of the areas around the world that had suffered terrible events and yet were still, in many ways, very beautiful. It was very much something that was pre-visualised, and I knew exactly what I wanted to do, and the kind of pictures that I wanted to take. Because I hadn't mounted an exhibition before, however, it was impossible to get anyone to agree to back me until I had spent a year or so shooting quite a substantial part of the project, and so initially at least it was a struggle to get things moving.

I agreed a book deal for 'For most of it I have no words' with the publisher Dewi Lewis quite early on, but getting an exhibition arranged was much harder. I've got a thick file of letters, probably around seventy or more, which details the correspondence I sent to galleries and the response was invariably negative. I even took a set of pictures to big photographic gatherings such as the festival in Arles, just trying to get some kind of feedback and I did make a few contacts this way. Notably I met up with the Blue Sky Gallery from Portland, which now represents me in America, and which recently sold an entire set of the exhibition for $15,000. I used every opportunity I had to go and see people with my pictures, because this personal contact is a hundred times more effective than just putting a selection of pictures in the post.

Eventually the Impressions Gallery in York took the show on, and it opened at the end of 1998 to coincide with the 50th anniversary of the signing of the UN Convention on Genocide. From here the show has toured extensively, and I've always tried to get to the gallery concerned on the day of hanging to make sure that the pictures work together in the space and that everything is presented in the correct sequence, something that is very important with this body of work. I'll normally take some extra prints with me so that a few pictures can be swapped around if the need arises.

Putting together a project such as this one was extremely involved: I worked hard to get publicity from a variety of quarters, and I also managed to get some generous sponsorship from Fotospeed who manufacture the Sterling Premium Printing Paper and Fotospeed Chemistry that I use. All these things were essential if the project was to be viable: I think if I put together another show at some point, the fact that I've got this one behind me will make things easier for me.

Simon Norfolk

Composition This picture was taken in the eastern part of Turkey where, in 1915, the Turkish government killed about one million of the Armenian minority who lived in the country at that time and deported many others. I wanted to show the landscape covered by snow as a metaphor for the erosion of memory, while the trees I saw planted along the edge of this field are a metaphor for the long line of deportees. However, because there is still conflict in this region, taking photographs of any kind is risky and there's always the chance of being picked up by the army, as I was on several occasions. Consequently I decided that it would take too long to set up a tripod, so I hand-held the Mamiya 6x6cm I was using and took just three frames from three different positions before leaving quickly. I had a similar shot to this one, but it didn't feature the grass in the foreground and is too sparse and two-dimensional. This was the only frame that had the grass and this extra detail helps the picture to have much more balance and shape.

Pointer Putting together an exhibition is one of the most satisfying ways of using your pictures, whether it's a show at a major gallery that you're putting on or a small display at your local library. Before you even start you have to make sure that you're really ready to go public: a theme for your work is essential and like Simon Norfolk, you must be sure of your own style, because work that's too derivative will be found out immediately. Making the right selection is the next problem: making rough prints will help you to see how your pictures work together, and it will give you the chance to get feedback from those whose opinion you trust. In the final analysis, however, you must have the confidence to make your own decisions about what to include, otherwise the exhibition will end up being selected by committee.

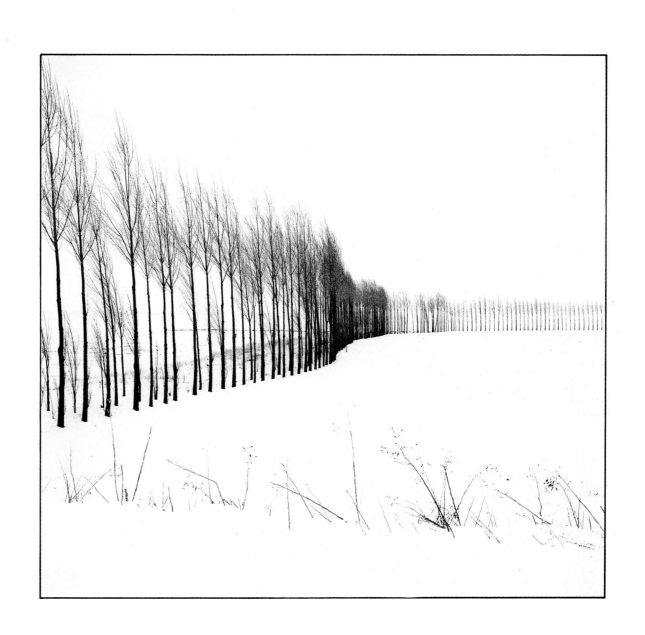

Websites

www.iol.i.e./gnorman-photography

Introduction Set up a personal website and you've established an exciting and cost effective way of showing your photographs to a potentially unlimited worldwide audience. Best of all, you'll be in charge of the content and the presentation and so you have far more freedom to express yourself than you would normally expect from a conventional exhibition outlet.

What You Will Need The first essential piece of equipment you require is a computer. The very minimum would be a 486 with Windows 95, and this would be the very minimum. Recommended though is a Pentium. Whatever computer you decide on should have at least 16 megabytes of RAM. Do remember though, your hard drive i.e. amount of space on your computer, will slowly be eaten up the more programs you load, which will in turn slow down each action you do. Therefore, 32 megabytes of RAM would be more realistic. You'll find this extra RAM really useful when scanning and editing.

Next you will need a good scanner, with a minimum resolution of 72 pixels per inch (ppi). Again, this is the very minimum. Higher resolution scanners are advised, because the quality of the scanned image will be even higher. However, there is a fine balance between image quality and its size in terms of megabytes. The greater the file size, the slower it will take to appear on the Internet. However, regardless of the resolution you save your image at, it will be no greater than the resolution of the computer screen, typically 72 or 96 ppi.

Once pictures are scanned, you could alter them on an image editing program. Photoshop is widespread. The capabilities of such programs are vast, but at a simple level you could create electronic frames and borders, lighten or darken your image, change its size or add a tone. Additionally, you could watermark your images, that is to say give it an electronic signature which will say that the image is yours. Although you cannot stop people copying your images from the Internet, at least if they appear again you can prove they are yours. Remember to save your image. The Internet supports gif or jpg, e.g. your image.jpg. Note, all names on the Internet are in lower case.

The time it takes an image to appear over the Internet is a function of its file size. For a benchmark, colour images should be approximately 80Kbytes in size, while black and white should be an 1/8th of the file size. This is based on an image measuring about 5cm x 3cm. It can also be useful to use very small images, known as thumbnails, which will download in a fraction of the time. Then, if people are more interested and want to see more detail, they can click on the thumbnail and a larger version will download. They will be more prepared to wait for something they asked for. For this to be effective, put a meaningful title against the thumbnail.

Now you need to put some text to your pages. If you're bringing text and images together and don't want to learn pure HTML, you can use programs such as Front Page or Page Maker, which are simple drop and drag web-editing programs. Each page you complete needs to be saved as a htm file, e.g. photos.htm, though the first one has to be called home.htm, which will subsequently serve as your home page.

www.martyknapp.com

cityart.net This highly successful website – currently getting over 2000 visitors a day – was created by web developer Debra Palmer and was considered so innovative and attractive to use that it was runner-up in two categories in a major competition for websites held by **The Times** newspaper. The site, which was created on less than 10 megabytes of space, contains forty-five examples of investment art in a series of galleries, complete with essential details such as price, condition of picture and so on. It also has links to several other sites of interest to photographers and investors, such as The Royal Photographic Gallery and Photographers in New York, a listing of dozens of top photographers, several of whom have themselves links to other sites.

How do I transfer my files to the Internet? First you need to register with an Internet Service Provider (ISP). These are widespread now and normally free. As well as providing you with an email address, they typically supply an amount of web space, e.g. 10 megabytes. You will want to give your website a name, so people can find you. If you register your website name with your ISP, invariably, their name will be the prefix to your site, i.e. www.isp name/your name.com. You could, however, register a unique name, without the mention of your ISP, which should only cost around £50 for two years, i.e. www.your site.com. This was the case with www.cityart.net, which was registered to give our website a professional-sounding name. Without getting technical, you have to ensure with your ISP that your registered name is 'pointing' to your site, i.e. web aliasing.

Having got your site name registered, you need to transfer your files to your web space. This sounds complicated, but actually isn't. You will probably use 'ftp', which stands for file transfer protocol. Basically, all you have to do is to dial up your ISP and via ftp, transfer your files to your web space. This is protected by a password which you set.

How will I advertise my site? How will I get visitors? Difficult one! Just type in 'photography' into any search engine and see how many sites exist. So how do you get ahead of the competition? Placing adverts in journals can cost an arm and a leg. However, there are electronic ways. For example, find a popular site, contact them and ask whether they will include a link to your site; cityart is one such site that is developing such links. You can also incorporate the META Tags, which are key words that define your web page, in terms of HTML.

Finally, remember to include your email address on your website, so that if anyone sees your pictures and wants to contact you about them, all they have to do is to click on your address.

Debra Palmer

Biographies

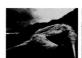 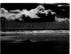 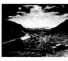 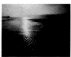

John Claridge was born in 1944 in London's East End and from the age of fifteen to seventeen, he worked in the photographic department of a London advertising agency. He decided early on that photography was his vocation, holding his first one-man show at the age of seventeen, and then working as assistant to American photographer David Montgomery for the next two years. He opened his first studio aged nineteen in London's City area, and since that time he's worked for most leading advertising agencies and clients in Europe, the USA and Japan. His work has been exhibited worldwide and he's been presented with over five hundred awards for photography, both editorial and commercial. Selected pictures have been auctioned at Christie's in London and his work is also held in the permanent collections of the Victoria & Albert Museum in London and The Arts Council of Great Britain Archives. He's published three books: **South American Portfolio** (1982), **One Hundred Photographs** (1987) and **Seven Days in Havana** (2000).

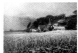

George Davison was born in Lowestoft, Suffolk in the UK in 1855 and took up photography at the age of thirty. He became a founder member of the Camera Club in 1885 and joined the Photographic Society of Great Britain, that later became the Royal Photographic Society, the following year. His famous pinhole landscape picture, 'The Onion Field', was taken in 1888 and the following year he was awarded a Gold Medal by the PSGB. Also in 1889 he was invited by George Eastman to become a non-executive director of the new UK firm, Eastman Photographic Materials, the company that later became Kodak. In 1898 he became Deputy Managing Director of the new Kodak Ltd., with a large gift of shares and a share option. This was later to make him a very rich man, although he was sacked from the company in 1913 for his anarchist activities. After a colourful and eventful life, he died in 1930.

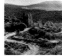 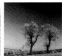 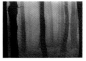

Adrian Ensor is one of Britain's finest black-and-white printers. He's a previous winner of the Ilford Printer of the Year Award – one of the UK's highest accolades for printers – and his London darkroom attracts orders from many of Britain's top photographers. Over the past eight years Adrian has been building a reputation as a gifted photographer as well, setting himself projects that he finds personally stimulating and then pursuing them tenaciously. His work has now been accepted by the prestigious Photographers' Gallery Print Room, where it's offered for sale alongside pictures from some of the world's leading photographers.

16 20 62 66 101

102

31 38 74

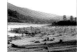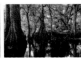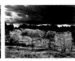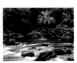

Bob Hudak, who was born in 1960, showed an early interest in photography. A small camera presented as a gift by a relative was taken on family trips and the resulting snapshots were just that: 'snapshots' of the typical scenes encountered on these outings. Having grown up in South Florida in the time before overdevelopment took hold, most days were spent in the area of woods and lakes not far from his home. Photography was never something of deep interest, however. Instead an interest in flying became apparent in his early teens and culminated in his obtaining his pilot's licence at the age of eighteen. The next four years were spent flying as much as possible with the intent of building time and operating a charter flight service. As time went on he gradually became somewhat disenchanted with the idea of flying for a living and around the same time he was shown a book of photographs by someone named Edward Weston. Seeing Weston's photographs left an impression that would dictate how the next sixteen years would be spent. Having seen the area in which he grew up, and South Florida in general, literally paved over from what it once was, his pursuit of landscape photography seemed, at least on a subconscious level, to be a way of looking for the youth that was lost along with the lakes and the woods. Bob works with large format cameras to enable him to make use of processes that require contact printing, such as Platinum, Palladium and Printing Out Paper. His prints are available for purchase through his website, which can be found at http://home.earthlink.net/~bhudak/lt.html.

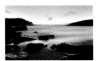

George Jackson was born in 1965 and was educated in northeast London. He left school at fifteen, and worked through an engineering apprenticeship in telecommunications. Always having had an interest in landscape photography, he acquired his first manual 35mm camera during a working holiday in Australia in 1989. Soon after returning home he began a part-time City & Guilds photography course at Redbridge College in east London, which he completed in 1997. Having achieved three distinctions for his landscape, black-and-white and colour portfolios in his work towards a full City & Guilds of London Certificate, George was entitled to join the Royal Photographic Society as a Licentiate. Among his explorations of great landscapes, the photographer has ventured to the Elan Valley in Wales, the West Highlands of Scotland and the abandoned industrial tin mines of Cornwall, as well as the Dingle Peninsular on the west coast of Ireland. A website, which features a selection of images, can be found at http://www.users.zetnet.co.uk/dingle-peninsular, while the email address to contact is gwjackson@zetnet.co.uk.

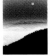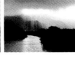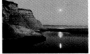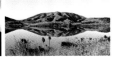

Marty Knapp has lived in, and photographed, California's Point Reyes National Seashore for over twenty years. He and his wife Jean make their home in Olema, the gateway to the National Seashore. His work captures dramatic moments of light in the landscape. His studio and gallery have received visitors from all over the world. Like Ansel Adams' Yosemite, or Weston's Point Lobos, Knapp's Point Reyes provides the viewer with an intimate look at one of the world's most beautiful landscapes. Known as a master printer, Knapp prints each of his limited edition photographs by hand and then selenium tones them for beauty and longevity. They are numbered, registered and signed before going into museum quality cotton mats. A catalogue of his images can be seen on his website at www.martyknapp.com and his email address is marty@martyknapp.com.

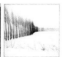

Carl Lyttle was born in Belfast in 1965, and took up photography at seventeen whilst doing A' levels, believing that it was better being in the darkroom than in maths class. He started work in Belfast as a junior at eighteen and left as a studio photographer at twenty-one to go to Bournemouth and Poole College of Art and Design. He left with distinctions and assisted the late great Christopher Joyce for a year and a half before travelling around the world. In 1991 he returned to London, won the first ever Association of Photographers Assistant Awards and went on to set up a still life studio in London's Soho. In 1997 after becoming bored with studio photography he changed direction to follow his first love of landscape and location photography. This has proved very successful and has led to location photography being ninety per cent of his work. He's worked on campaigns for Audi, Chrysler, Visteon, BT, Virgin and Ben Sherman to name but a few. He won a merit award at the 1999 AOP awards and tries very, very hard to pursue personal landscape projects wherever possible. In April 1999 he held his first large solo exhibition at the Association Gallery in London, featuring a selection of personal work taken at Nevada's Burning Man Festival.

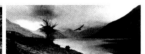

Simon Norfolk was born in Lagos, Nigeria, in 1963 and from 1988–90 studied Documentary Photography at Gwent College in Newport. He learned photojournalism through working for the far-left press through the early nineties, becoming staff photographer for **Living Marxism** magazine from 1990–1994. He undertook extensive work on fascism and the far-right, especially the British National Party and also worked over a long period as a photojournalist on anti-racism issues, the Poll Tax and Northern Ireland. He was assigned to eastern Europe at the fall of the Berlin Wall, and covered the Gulf War. His work has been published in all the UK broadsheets and many European magazines. He began his much-acclaimed 'For Most Of It I Have No Words' project in 1994 and this was premiered at the Impressions Gallery in York at the end of 1998. The show has since gone on to tour around the UK, the US, Canada and Europe. Another exhibition, 'After The Fall: 10 years after the Berlin Wall', ran during early 1999 at the Tom Blau Gallery in London. Simon has also been featured in many other exhibitions including the John Kobal Portrait Awards at the National Portrait Gallery in London in 1998 and the Association of Photographers Award Winners Show at The Barbican in London in 1997 and 1998. He was also overall winner of the Amnesty International Photography Contest, organised in 1998 to celebrate the 50th anniversary of the UN Declaration of Human Rights, and also gained four runners-up awards.

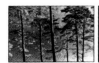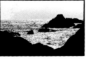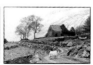

Giles Norman has been taking photographs for the past seventeen years and inspired by the 'street' or 'real' photography of the early and mid-part of this century, he takes care to present his pictures as he sees them, with no filters or complicated techniques employed to serve as a distraction. When not travelling around Eire with his camera looking for more subjects, he lives in Kinsale on Ireland's south-west coast with his wife and two children. He opened his first photographic gallery there in 1988, quickly gaining recognition throughout the country and abroad for his unique black-and-white landscape images. He has since moved to a larger gallery in Kinsale in order to house his continuously expanding portfolio of photographs while in 1994, he opened a second gallery, just off Grafton Street in Dublin. His website, which can be found at www.iol.i.e./gnorman-photography, contains details of over a hundred hand-printed and signed pictures which can be ordered direct from the galleries.

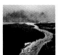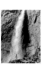

Jerry Olson is a native of North Dakota. He was a photographer's mate in the US Navy from 1960–64 and then attended the University of North Dakota for two years in preparation for his training at the Brooks Institute of Photography in Santa Barbara, California. There he earned his Bachelor of Professional Arts degree in photography, with a major in Illustration. He has been employed for thirty years at the University of North Dakota at Grand Forks, North Dakota and in his spare time, he specialises in landscape photography. He is owned by his two cats Skippy and Scooter, who can be seen along with many other black-and-white and nature photographs, and a selection of his digital colour images, on his website at: http://www.westernechoes.com.

Martin Reed is working out his fascination with photography via the unorthodox route of becoming a specialist retailer in its materials. His outlet, Silverprint, was set up in the UK in 1984 with the aim of providing a 'delicatessen' service for photographers and printers, particularly those working in black and white. Among the more unusual ranges it provides are the more obscure high quality fibre-based papers, raw chemicals for alternative processes and a large choice of archival storage and presentation materials. Silverprint's address is 12 Valentine Place, London, SE1 8QH. Website: http://www.silverprint.co.uk. email: sales@silverprint.co.uk.

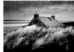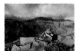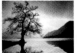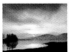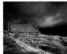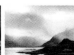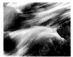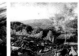

Tom Richardson's passion for landscape photography, which now spans more than two decades, was born out of love for the fells and mountains of the UK. For over forty years most of his spare time has been spent wandering these lonely places, his only regret being that discovery of photography didn't come along until later. It wasn't until the birth of his eldest daughter that he bought his first camera and joined the local photographic society. Printing soon after became an essential and self taught, Tom found trial and error the best way to learn. Success followed, with acceptances in exhibitions from Kuwait to Edinburgh. Moving away from club photography, his work has featured in many magazines and yearbooks, notably a major profile in the UK magazine **Practical Photography**, while in 1996 he won the prestigious Ilford Printer of the Year Award. Other wins and awards include the Ballantine's Whisky International, two sections of BNFL's 'Best of Cumbria' competition and acceptances in five of the six editions of **Best of Friends**, the yearbook of the Creative Monochrome group.

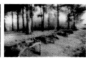

Dr Tim Rudman EFIAP, FRPS, FBPPA Hon, FRSA, ASIIPC, has built up an enormous reputation as a master printer and fine art photographer. He's contributed regularly to every major photographic magazine in the UK, is currently a feature writer for **Photo Art International** and has produced two books. **The Photographer's Master Printing Course**, produced in 1994, has been a best seller since it was launched and **The Master Photographer's Lith Printing Course** followed in 1998. Dr Rudman is also a Member of the London Salon of Photography and has exhibited his work worldwide, having gained numerous international awards and gold medals in the process. He's also a previous AP/Ilford Printer of the Year Award winner, a member of the Royal Photographic Society's Visual Arts Pictorial Panel and Chairman of the Photographic Printing Panel. He's conducted numerous workshops in the UK, Spain and Australia, and his work is represented in the Permanent Collection of the RPS, the Tyng Collection and various private collections.

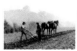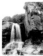

Frank Meadow Sutcliffe was one of the Victorian era's most celebrated photographers. Born in 1853, he worked from the fishing town of Whitby in the north-east of England from the beginning of his career in 1875 using the early photographic process known as wet collodian, though he soon switched to dry plates which were easier to work with. Despite his awkward equipment – Sutcliffe used full plate cameras that were constructed from brass and mahogany – he was able to create images of such unsurpassed elegance and sensitivity that even today, they are considered exceptional for their quality. His photographs, almost all of Whitby and its environs, captured a truth not available to those working at the time with brushes or pencils. Sutcliffe retired from photography in 1922 and became curator of the Whitby Literary and Philosophical Society, a position he held until his death in 1941. Fortunately, his collection of images remains intact, and can be viewed at The Sutcliffe Gallery, 1 Flowergate, Whitby, North Yorkshire, England. Website address: www.sutcliffe-gallery.co.uk. Tel: 01947-602239.

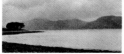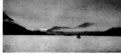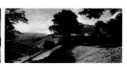

John Swannell is one of the UK's best-known and most successful photographers. He was born in 1946 and after leaving school at sixteen, he worked first as an assistant at **Vogue** Studios and then joined David Bailey for four years before leaving and setting up his own studio. He spent the next ten years travelling and working for magazines such as **Vogue, Harpers & Queen, The Sunday Times** and **The Tatler**. During this time he developed his very distinctive, individual style in both fashion and beauty photography. In 1989 he had a one-man show at The Royal Academy in Edinburgh, followed in 1990 by an exhibition at The National Portrait Gallery in Edinburgh. In July of the same year The Royal Photographic Society held a retrospective of his fashion work and a year later a show of his nudes was exhibited at The Hamilton Gallery. John was awarded a Fellowship of the RPS in 1993, one of the youngest members to have achieved this status, and the following year, The Princess of Wales personally commissioned a portrait of herself with her sons from him. From November 1996 to March 1997 John had a one-man show of his portraits at the National Portrait Gallery in London to celebrate the publication of his book **Twenty Years On**, and the pictures are now held in the Gallery's archives. The Victoria & Albert, the National Portrait Gallery in Scotland and the Royal Photographic Society also now have many of his works in their permanent collections. John has published three books to date: **Fine Lines** (1982), **Naked Landscape** (1986) and **Twenty Years On** (1996).

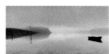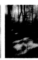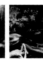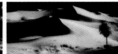

Michael Trevillion started a career as a photographer when family connections got him a job as a messenger for a photographic laboratory. After watching over the shoulder of others for a couple of months he brazenly applied for a job as a fully experienced printer at another lab and got it. After a succession of printing jobs – he found that he hated printing other people's work – he helped to set up Metro Imaging at the tender age of twenty-three. Five years later, despite the business growing well (it's now one of the UK's biggest and most respected printers) he decided to sell his half of it to become a photographer. He had no formal training and had picked up most of his knowledge by talking to photographers who had come into Metro, but since then he's made a big success of his new career. He now produces pictures for book covers on a regular basis, as well as overseeing his own picture library which features the sometimes quirky but always innovative work of photographers he admires. Financially, he says, it's been downhill all the way since he sold his share of Metro, but he loves his career and reckons it beats working for a living! The Trevillion Picture Library website: www.trevillion.com. Email: michael@trevillion.com. Tel: 020-8740 9005.

Glossary

Backlighting
Light that's coming from a position in front of the camera and illuminating the subject from behind.

Bounced Flash
Flash that's been reflected from a surface such as a wall or ceiling to diffuse the light.

Cable Release
A flexible device that screws into the camera's shutter release button and activates the shutter without the need to touch the camera.

Camera Movements
Vertical and swing movements that can be made with the lens and the film plane on a studio camera to perform various functions, such as increased depth of field and correction of converging verticals.

Compressed Perspective
Distant perspective that's been brought up close by the use of a telephoto lens.

Depth of Field
The distance in front and behind the point at which a lens is focused that will be rendered acceptably sharp. It increases when the aperture is made smaller and becomes smaller when the lens is focused at close quarters.

Dodging
The holding back of certain areas of the negative during printing to reduce print density, allied to the selective increase of exposure to certain areas of the print that require increased density.

Downrating
The opposite to uprating and primarily done to reduce contrast. The film is shot at a lower ISO rating and to compensate for what is effectively overexposure, the film is developed for a shorter time.

Dual Toning
The technique of placing a print in two separate toning baths to pick up elements of both colours.

Farmer's Reducer
A mixture of potassium ferricyanide and sodium thiosulphate that will lighten selective areas of a print.

Field Camera
A large format camera that has been specially designed to be used on location.

Fill-in Flash
A weakened burst of flash that can be used to subtly fill in the shadows on a subject's face.

Filter Factor
An indication of the amount the exposure needs to be increased to allow for the use of a filter. A x2 filter needs one stop extra exposure, x3 one-and-a-half stops more and x4 two stops more.

Graduated Neutral Density Filter
A filter that features a denser area towards its top that helps to even out the contrast levels in a picture if the sky is much brighter than the rest of the scene (see **Neutral Density Filter**).

High Key
A picture that consists almost entirely of light tones.

Hyperfocal Distance
The distance between the lens and the nearest point of acceptably sharp focus when the lens is focused for infinity.

Infrared film
A film that responds to the different reflecting powers and transparencies of objects in the picture to infrared and visible radiation, producing a series of bizarre tones.

Lith Printing Paper
A printing paper that increases the contrast levels in a scene while allowing shadow detail to be retained. Its characteristic feature is a pink tone.

Low Key

A picture that consists almost entirely of dark tones.

Mirror Lock

A lever on an SLR camera that allows the camera's mirror to be locked in the up position before an exposure is made to help reduce vibration.

Monopod

A form of support for the camera that utilises one leg, which makes it very easy to set up and move.

Neutral Density Filter

Used to cut down the light reaching a film by a stated amount and absorbs all wavelengths almost equally, ensuring no influence on the tones each colour will record as on black-and-white film.

Pinhole Camera

A camera that relies on a tiny hole to resolve its image rather than a lens.

Rangefinder Camera

A camera that features two separate images in the viewfinder that come together as the lens is focused.

Selenium Toning

A brief immersion in selenium toner diluted at about one part concentrate to fifteen parts water should not change print image colour but it will improve the archival permanence of the print. The toner must be used in well-ventilated conditions.

Spot Meter

A meter that is designed to give an accurate meter reading in difficult lighting conditions by gathering information selectively from three to four areas of a scene.

Tapestry Paper

Manufactured by Fotospeed, this is a heavyweight paper with a textured finish.

Thiocarbamide toning

A two-bath process that can, according to relative strengths of the components in the toning stage, give a variety of tones ranging from dark brown to yellow brown.

Uprating

Rating a film at a speed higher than its nominal rating and then compensating for the underexposure that takes place by increasing film development.

Variable Contrast Paper

Photographic paper that can produce different levels of contrast depending on the filtration it receives.

Acknowledgements Many thanks to all those who have contributed so very much to this book. To Angie Patchell, who has overseen and edited the whole project, and whose enthusiasm has helped immeasurably to drive it forwards; to Dan Moscrop at Navy Blue Design Consultants, who has worked so hard to turn a collection of pictures into a cohesive and visually stunning volume of work; to Brian Morris at RotoVision, whose belief and support for the project has been invaluable; to Frank and Beryl Hope for all their faith in me; and to all the photographers who have contributed their work, and their expertise, so willingly, and who had faith in the book even when it was but a mere twinkle in the publisher's eye.

The Association of Photographers

Based in London, the Association of Photographers has a membership of advertising, editorial and fashion photographers, and photographic assistants, in excess of 1,400, and it's also supported by agents, printers, manufacturers and suppliers of photographic equipment, as well as affiliated colleges. The Association, which supports a large and superbly presented gallery, is dedicated to fighting for photographers' rights in addition to promoting the work of contemporary photographers. Contact details: 020 7739 6669, email: aop@dircon.co.uk or visit the website at www.aophoto.co.uk.